4th Ed

The Price Guide to
Wallace Nutting
Pictures

by
Michael Ivankovich

Published by:
Diamond Press
P.O. Box 2458
Doylestown, PA 18901

4th Edition

The Price Guide to
Wallace Nutting
Pictures

Copyright @ 1991, Diamond Press

Library of Congress Catalog Card Number: 90-086127
ISBN: 0-9615843-9-4

Published By:
Diamond Press
P.O. Box 2458 * Doylestown, PA 18901
(215) 345-6094

Other Wallace Nutting Reference Books Available from Diamond Press
(add $2.00 P&H for each book ordered)

The Price Guide to Wallace Nutting Pictures, 4th Edition, by Michael Ivankovich ($14.95)

The Guide to Wallace Nutting Furniture, by Michael Ivankovich ($14.95)

The Alphabetical and Numerical Index to Wallace Nutting Pictures, by Michael Ivankovich ($14.95)

Wallace Nutting, by Louis MacKeil ($7.95)

The Wallace Nutting General (Furniture) Catalog, Supreme Edition, by Wallace Nutting ($13.95)

The Guide to Wallace Nutting-like Photographers of the Early 20th Century, by Michael Ivankovich ($9.95)

Contents

Wallace Nutting
1861-1941

Introduction
to
Wallace Nutting Pictures

Wallace Nutting was America's foremost photographer. Between 1900 and his death in 1941, he sold literally millions of hand-colored pictures with his work achieving such enormous popularity that hardly an American middle-class household was without one during the first quarter of the twentieth century.

Beginning in 1897, Wallace Nutting went on to take nearly 50,000 pictures. Most failed to meet his high standards and were destroyed. Of the 10,000 that he did keep, most were sold in limited numbers, while others were not sold commercially at all. Wallace Nutting would simply take photos for use in his lectures, research, or for his friends, and those particular pictures would never be hand-colored or sold to the general public.

By most estimates, only 2500 different titles were sold commercially. Some of these titles were extremely successful and sold in very large numbers. Titles like *The Swimming Pool, Larkspur, A Barre Brook, An Afternoon Tea,* and *Honeymoon Drive* were so popular that tens-of-thousands of each picture were sold.

Other titles were introduced commercially, failed to generate any significant sales, and were withdrawn. For example, titles like *The Belles of San Gabriel, Southbury Water,* and *Mohonk House from Spring Path* appear in the **1912 Picture Catalog** but do not appear in the **1915 Expansible Catalog,** indicating a low level of sales in the 1912-15 period.

Literally millions of these hand-colored platinotype pictures were sold. They were beautiful, inexpensive, and provided many people

1

with the opportunity to decorate the walls of their homes at a very reasonable price.

As with many other things, however, people tended to tire of them after 20-30 years. Many were thrown away; others were stored in attics and basements. Only within the past 25 years, as they have been recycled through Auctions and Estate Sales, have they regained much of their previous popularity.

In the 1960's Wallace Nutting pictures could sometimes be purchased for as little as $.50 or $1.00 each or, for all practical purposes, for the price of the frame.

By the early 1970's, prices had increased to the $10-$50 level. Some people assembled fabulous collections during this period. Collections of several hundred pictures were not uncommon. One individual assembled a collection of nearly 1000 pictures, all framed and hanging in one house.

By the 1980's, Wallace Nutting collecting had caught on and prices began to escalate. In fact, prices more than doubled in some categories between 1986-88 alone and, as we enter the 1990's, prices remain as strong as ever, especially for the best pictures in the most unusual categories.

Why? What's behind all this interest in Wallace Nutting?

First and foremost was the formation of the **Wallace Nutting Collector's Club**. Founded by **Justine and George Monro** in 1973, this club served as the initial gathering place for collectors to buy, sell, and trade Wallace Nutting pictures. More importantly, it served as the central source of information on Wallace Nutting. For nearly 20 years the Monro's have gathered and shared Wallace Nutting material with collectors all over the country. This has not

only heightened awareness and educated people about Wallace Nutting, but began to create a demand for his pictures as well. (Note: The Wallace Nutting Collector's Club is still very active. You can contact either Diamond Press or the Monros directly for further membership information.)

The second reason for this increased interest in Wallace Nutting was the publication of several books relating to Wallace Nutting pictures. Four important books were written concerning the "Who-What-Where-How" questions asked by most collectors.

Who was Wallace Nutting? The late Louis MacKeil covered this in his 1982 book **"Wallace Nutting"**. This biographical-type book covered such topics as *"Wallace Nutting, the Man"; "Wallace Nutting's Picture Business"; "Wallace Nutting's Furniture Reproduction Business";* and *"Books Written by Wallace Nutting"*. This easy-to-read book covered all key parts of his life and provided collectors with a fundamental understanding of **Who** Wallace Nutting was.

What do his pictures look like? In the absence of seeing huge collections in person, the publication of Wallace Nutting's 1915 salesman's picture catalog, the **"Wallace Nutting Expansible Catalog"**, enabled collectors to visually observe nearly 900 pictures that had actually been sold...and that were still available to collect. (Unfortunately, at the time this 4th edition goes to press, this book is out of print).

Where was my picture taken? The 1988 release of **"The Alphabetical and Numerical Index to Wallace Nutting Pictures"** covered that question. Serious collectors take Wallace Nutting much further than simply buying a picture and hanging it upon their wall. They want to know where it was taken...Is it an early or late picture?...What is its Studio #?...Does it appear in any

3

6 Wallace Nutting Reference Books

other books? **"The Alphabetical/Numerical Index"** answered all these questions...and more...for collectors.

How much is my picture worth? Beginning with the 1st edition in 1984, the 2nd edition in 1986, the 3rd edition in 1989, and now this 4th edition, **"The Price Guide To Wallace Nutting Pictures"** answers this very important question. By showing collectors and dealers what key characteristics to look for...what is common and what is rare...what the difference is between a good and a great picture...this guide helps collectors to gauge the approximate value of any Wallace Nutting Picture.

A fifth book, **"The Guide to Wallace Nutting Furniture"**, was released in 1990. Although this book focuses primarily upon Wallace Nutting's furniture reproduction business, it does cover important information on Wallace Nutting pictures and books. And more importantly, this book further stimulated interest in Wallace Nutting pictures simply because of the synergy of the Wallace Nutting name.

The net effect of these 5 books has been to create a more informed, better educated group of collectors. As in other fields of collecting, the more knowledgeable collectors become, the more dedicated they are to their specialized field of collecting.

The third key factor in this expanding popularity of Wallace Nutting pictures has been their increased visibility throughout the antique trade. Nearly every trade paper and magazine in the country has carried several articles on Wallace Nutting over the past few years. This has helped to educate people who aren't necessarily Wallace Nutting collectors, and who wouldn't normally have had the opportunity to read about the subject.

This increased awareness has led many dealers to now actively add Wallace Nutting pictures to their inventory. Both dealers and Auction Houses also now actively advertise Wallace Nutting pictures in the trade papers. And, several dozen dealers are now even *specializing* in them, establishing strong followings at various shows and markets around the country.

This specialization in Wallace Nutting has even carried into the Auction field. In March 1988 the first all-Wallace Nutting auction was held in Lee, Massachusetts. Nearly 1000 pictures from the Gordon Chamberlain collection were offered in a 2-day sale, with strong prices indicating a high level of interest in Wallace Nutting.

This was followed 6 months later by the Michael Ivankovich Antiques Auction in Framingham, Massachusetts. This Auction represented the first all-Wallace Nutting *Consignment Auction,* with nearly 500 lots of Wallace Nutting pictures, books, and furniture, consigned by 25 collectors and dealers...all offered in a 1 day Auction. 300 people attended this sale and their high level of enthusiasm has led to 7 more all-Wallace Nutting Auctions in 1989-1990, with 3 more scheduled to take place in 1991.

These Wallace Nutting Auctions have now become the central marketplace for Wallace Nutting pictures throughout the country. They provide the opportunity for collectors and dealers to compete for a wide variety of Wallace Nutting pictures, ranging from the more common inventory-type untitled Exterior scenes...to the best and rarest pictures in the country...all sold in one location, at one time, without limit or reserve.

These Auctions also give **sellers** of Wallace Nutting pictures an excellent means of reaching the top collectors in the country. Whether a private individual selling out an entire collection of rare and unusual pictures, a collector weeding out lower-end pictures in

order to trade up, or a dealer liquidating unsold Wallace Nutting inventory, these Auctions attract collectors and enthusiasts from around the country who all have one thing in common...a love for Wallace Nutting pictures.

But most importantly of all, the popularity of Wallace Nutting pictures can be attributed to their universal appeal. Young people love them because they show our country as it once was...the way they have never seen it. Older people love them because of the memories of simpler times past...no skyscrapers...no telephone poles...no super highways...no pollution.

The objective of this book is not to set prices, but to **report** prices. A good Price Guide does not and should not set prices. Rather the marketplace should set prices by what people are willing to pay for particular pieces.

Many people will be amazed at the prices they see in this 4th edition. Some will think *"I've never seen prices like these at my local auction. These prices are way too high"*. Not so. You should be aware that prices will generally vary by region of the country. Some regions have a much higher level of interest in Wallace Nutting than others, and therefore prices are generally the highest where the interest is the greatest. Most prices reported in Chapter 8 represent prices *actually paid.*

Others may think *"I saw a picture go much higher at my local auction. Therefore some of these prices are too low"*. In some cases, this may be true. However, you must remember the nature of Auctions: some items sell for considerably more than their true worth, many items sell for their approximate worth, and some items are downright bargains (which are then frequently purchased and marked-up by knowledgeable dealers). That's the nature of auctions.

The Swimming Pool is one of the most common
Exterior scenes that you will find.
Est. Value: $75 - $150

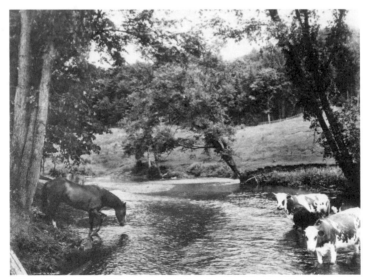

The Meeting Place...Add a horse and a few cows
to the stream and the value jumps quite considerably.
Est. Value: $1500 - $2750

Secondly, prices included here are representative of what is being paid around the country. I obviously cannot include the price of all Wallace Nutting pictures sold everywhere. After the publication of the 2nd edition Price Guide, I had a dealer from New York write me a nasty letter, and then follow it up with a loud phone call, accusing me of "ruining her Nutting business". It seems that she had regularly been charging, and getting, higher prices than I had reported in the Price Guide. She became upset when a customer questioned her prices as being out of line, using the Price Guide by "that guy in Pennsylvania" as a reference.

I tried to explain to her that if she was able to get higher prices than I reported, great. But just because she was able to get a certain price in the Hudson River Valley, that didn't mean the same price structure held up in the Delaware River Valley or the Tennessee River Valley.

My point here is that regional prices do exist. Although we have seen a definite trend toward nationally recognized price levels since the introduction of the 1st edition of this book in 1984, prices will still vary around the country, depending upon the local level of interest in Wallace Nutting, and the current economic climate there. In some regions, the higher levels in the Price Chart will apply; in others, the lower levels may apply for the same picture.

The prices and price ranges listed in this book are intended solely to help the reader establish a fair and approximate range of values for various Wallace Nutting pictures. It will be helpful to all levels of collectors or dealers in differentiating excellent pictures from average pictures, and rare pictures from common pictures.

The Pricing Chart in Chapter 2 is a unique guide that can be used in establishing a "ballpark" value on any Wallace Nutting picture.

It provides useful rules of thumb and will be of value to both the person buying, or selling, a particular picture.

Chapter 8 includes the actual sale price, or in a few instances, the asking price, on several thousand pictures. This list has been compiled from many sources over the past 1-18 months and represents current prices that have either been:

> * Paid at auction (primarily Michael Ivankovich Antiques Auctions of 1989-90, but also in many regional Auction Houses as well).

> * Paid at the retail level (including antiques shows, flea markets, and direct mail sales).

> * Observed at antique shows, flea markets, trade paper advertisements, dealer mail order lists, and the Wallace Nutting Collector's Club Annual Convention.

The titles in Chapter 8 represent a comprehensive cross-section of pictures that have come into the marketplace recently. Those titles that appear several times are generally indicative of more common pictures. And, for the first time, this 4th edition now carries a **Numerical Grading System** to help you correlate condition with price.

One final word of caution. Just because the $5000 level has nearly been reached, and that the $1000 level has been surpassed on numerous occasions, not all Wallace Nutting pictures are worth $1000. Nor will they probably ever be worth that much.

One of the biggest problems with record prices is that they attract a great deal of public attention, especially from dealers and

collectors. Dealers read a portion of an article, figure their picture is special, and raise the price from $100 to $500. And the picture sits...and sits...and sits. I've seen so many common overpriced pictures lately that I can't imagine anyone ever buying them.

Or what's worse, dealers will raise the price of a $100 picture to $275, and then "drop" the price to $200 for the first semi-serious buyer who comes along. Who's getting the bargain, the buyer...or the seller?

Just remember, only the rarest pictures in the absolute best condition will sell at top prices. Everything else is worth proportionately less. And, as the Wallace Nutting market becomes more sophisticated and mature, condition will become increasingly important.

My advice to you:

> * Read as much as you can on the subject of Wallace Nutting. Observe and study as many pictures as possible in order to learn the difference between average, good, and great pictures.

> * As with all other forms of antiques and collectibles, buy the best quality that you can afford. In the past, average pictures have increased in value at an average pace. Great pictures have appreciated at a much greater rate.

> * But most importantly, buy what you like...because you like it...**not** because you think it will increase in value. Remember that all markets, whether it be Antiques, Commodities, Real Estate, etc., have peaks and valleys. Don't let anyone "guarantee" that a picture will increase in value. **There are no guarantees in this business.**

Small, clean Untitled Exterior scenes
are still available in the $25 - $50 range.

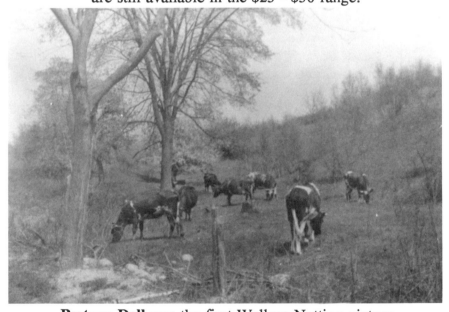

Pasture Dell was the first Wallace Nutting picture
to break the $1000.00 level at Auction

But regardless of price, whether paying $25 for a small Untitled Exterior or $1500 for a Cow scene, Wallace Nutting pictures are a pleasure to collect. They are colorful, beautiful, and historical. They can be purchased at antique shops or shows, at garage sales or flea markets, at auctions or through the mail. And bargains are still out there, if you look hard enough.

Keep looking, because Wallace Nutting pictures have finally come of age.

Wallace Nutting Auction Catalogs

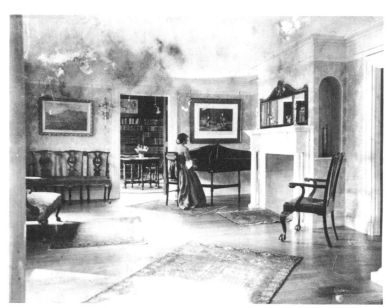

A Picture in poor condition.

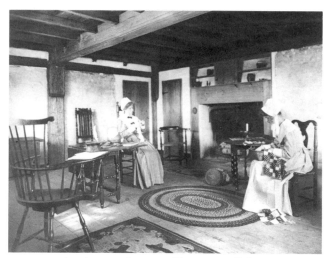

A picture in excellent condition.
Subject matter, condition, and size
are all important in determining value.

Chapter 1

Understanding the Main Determinants of Value

Several basic concepts must be understood about the prices and values of Wallace Nutting Pictures. As with all other antiques, prices are very subjective. A dealer can charge what he or she feels the market will bear. Some dealers price things low in order to turn them over quickly; other dealers ask top dollar and are willing to sit on an item until they get their price. In either case, you must pay the price or pass up the picture.

The price of Wallace Nutting pictures also depends upon several other factors.

> **Subject Matter...**What is the topic or theme of the picture? Is it common or rare? How many people are interested in owning that same picture?

> **Condition...**Is the picture in poor or excellent condition? What is the mat like? Is the frame attractive or ugly? How difficult will it be to find the same picture in the same condition?

> **Size...**How big is the picture itself? The matting? The frame?

Each of these items must be considered in arriving at the final estimated value.

A Birch Hilltop is a common Exterior scene with birches

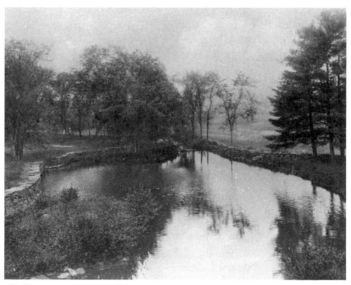

A Barre Brook is a common Exterior brook scene

Subject Matter of Wallace Nutting Pictures

There are several primary categories of Wallace Nutting Pictures.

Exterior Scenes

Exterior scenes are what most people associate with Wallace Nutting and they comprise the largest segment of his pictures. These would include pictures of :

> Apple Blossoms
> Birches
> Country Lanes
> Streams
> Rivers
> Ponds or Lakes
> Fall Scenes

Wallace Nutting worked out of Framingham, Massachusetts and sold a large percentage of his pictures in New England. Winters were very long and cold and people generally desired pleasant, optimistic signs of the warmer weather ahead. As a result, these nice warm-weather pictures were the most popular and sold the best. Being an observant businessman, Nutting produced what the public would buy. This accounts for the very large percentage (85%) of Exterior pictures that may be found.

Since they were so popular then, and since so many were produced, they are fairly common today. The fact that they are more common and readily available is the reason for their relatively low price when compared to other Wallace Nutting pictures.

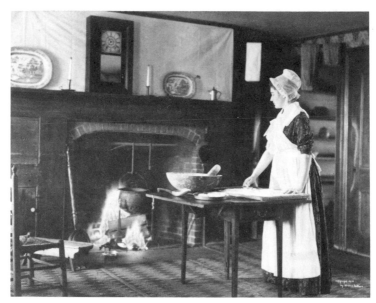

Is the Fire Ready?...a typical Interior scene

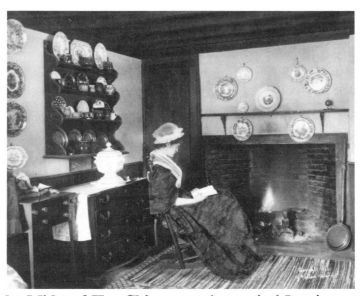

In the Midst of Her China...another typical Interior scene.

18

Interior Scenes

These were pictures taken inside old houses and usually had women dressed in long dresses and bonnets. Some were done in primitive settings, others in more formal surroundings. They included period furniture and were quite charming.

Although these were popular, they were not nearly as popular as the Exterior Scenes, accounting for only approximately 10% of all Wallace Nutting pictures. Thus, the Law of Supply and Demand holds true here. Since fewer were originally done, fewer are available today. With so few available, demand has pushed the prices of some to 2-3 times higher then comparable Exterior scenes.

All things being equal, i.e., size and condition, *a basic rule of thumb is that Interior scenes are worth approximately 2-3 times as much as Exterior scenes.*

Miscellaneous Unusual Topics

This 3rd category somewhat overlaps the Exterior and Interior Categories, and includes many sub-categories as well. But this is the most desirable area for the serious or advanced collector. It is also the category least understood by beginning collectors.

Collectors usually begin buying Exterior scenes because of their lower prices, and then progress to buying Interior scenes. But once the collector becomes hooked on Wallace Nutting collecting, the real search begins for rare and unusual pictures.

Wallace Nutting collectors are like any other collector; they are always looking for rare and unusual items to add to their collection.

A Patchwork Siesta...an Interior scene with a **Child**

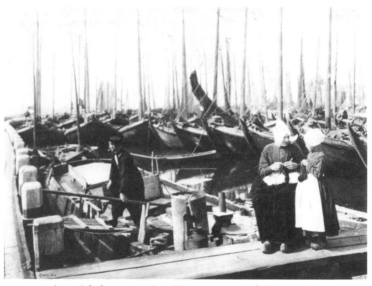

An Airing at the Haven...a triple rarity
with a **Child**, a **Man,** in a **Foreign** setting

They travel long distances, scour flea markets and antique shows, and pay whatever it takes to acquire a special picture.

Few collectors will go too far out of their way to purchase an Exterior Scene. They are too common and easy to obtain. Even Interior Scenes must be something very unusual before the serious collector becomes motivated to buy. But once you have a rare and unusual picture in your hands, you have something very desirable to all levels of Wallace Nutting collectors.

Some of the Unusual Topics would include:

> Foreign Scenes
> Seascapes
> Pictures with Animals
> Exteriors with People
> Pictures with Children
> Pictures with Men
> Floral Arrangements
> Snow Scenes

All Unusual Topics combined account for only approximately 5% of all Wallace Nutting pictures.

I'll cover more on this topic later.

Condition

Once you have determined the **subject matter** of your picture, the next step in determining the value is to assess its condition because **condition is the most important determinant of value.** The rarest picture in poor condition has very little value; a common Exterior in excellent condition is still a very desirable piece.

There are several important characteristics to look for in determining condition.

The Picture Itself

Many pictures are nearly 100 years old and, as time has passed, their condition has deteriorated. Some hung on walls that received years of direct sunlight, causing the colors to fade. Others were stored in damp basements where condensation formed and caused spots, foxing, or other blemishes to occur.

Secondly, each picture was individually hand-colored, not colored by machine. Whenever something is manually produced in large numbers, some items are inevitably going to look better than others.

Finally, although quality standards were set, some hand-tinted pictures were almost masterpieces while others barely met the minimum standards. Wallace Nutting also sold the business at one time, so different minimum standards were in place at various times between 1905 and 1941.

It should therefore be understood that the quality of pictures can vary widely. Experience is your best guide. The more pictures you see, the better you will be able to differentiate between an average and an excellent piece.

Matting

The matting is the tan backing that the picture is mounted upon and which generally contains the title and signature. This is really the most susceptible to damage. All too often, as pictures were stored

in basements or attics, water would get on the matting because of basement floods or attic leaks. Once a matting becomes water-stained, it is almost impossible to remove.

Severe water stains are very unsightly and definitely detract from the beauty and value of a picture. Although some people will still buy a picture with a water-stained mat, many collectors will shy away unless the picture itself is very rare and of high quality. Therefore, *a water-stained mat definitely decreases the value of a picture, sometimes by as much as 25% - 50%.*

Another problem with matting is yellowing from the sun. It was not uncommon for a picture to hang in direct sunlight for many years. A yellowed mat is usually accompanied by a faded picture, thus significantly reducing the value.

Spotting or foxing on the mat is another problem. Not as severe as water stains, spots form because of age, dampness, fungus growth, the type of backing used, or any of several other reasons. They can sometimes be removed but this should only be attempted by a qualified, experienced individual.

It goes without saying that a torn mat will significantly reduce the value of a picture.

Sometimes mat damage may be camouflaged by an overmat. There is nothing wrong with this because the picture itself is the most important part and, if overmatting will enhance the beauty of a picture, fine. But just be aware that an overmat is probably a sign of a damaged mat and is no substitute for a mat in excellent condition. It will also reduce the value of the picture. **As a general rule,** *overmatted pictures may be worth up to 50% less than pictures with clean, original mats.*

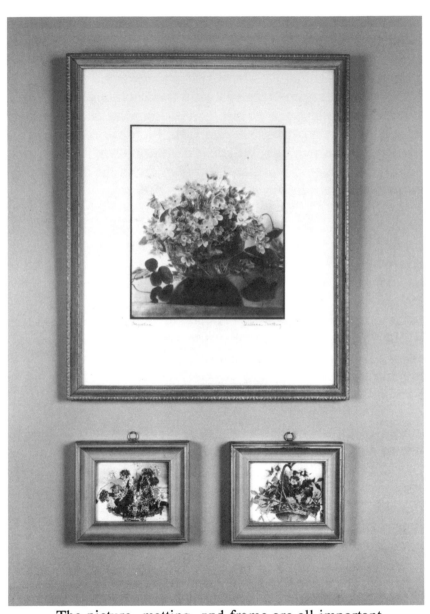

The picture, matting, and frame are all important
when evaluating the overall condition of a picture.

Sometimes you will see a picture with a black border instead of an indented mat. Stories that the black border represents pictures done after Wallace Nutting's death are not true. These are also not reproductions. Rather, this was just another style that Wallace Nutting tried to market in the 1930's. Most black-bordered pictures are brightly colored (vs. only partial coloring on most early pictures). Frequently original labels can be found on the back of these pictures. Some people love these black bordered pictures; others do not. **As a general rule, *pictures with the black borders are somewhat less desirable than those without it.***

Frame

The frame is very important to the overall beauty of a picture. The solid brown wooden frame is the most common and desirable type. Wallace Nutting framed many of the pictures he sold, but some of his large customers (e.g., some Department Stores) preferred to buy their pictures unframed. They would then frame them according to their customer's tastes, charge extra for the framing, and presumably save shipping charges as well. This accounts for the wide variety of frames you may see.

Only when you have seen a Wallace Nutting picture in a perfect frame do you realize the importance of the frame to the overall picture. Chipped, pitted, painted, or unsightly frames can spoil an otherwise perfect picture.

Although frames are replaceable (whereas the picture and original mat are not), the cost of replacing a frame can turn a good buy into a bad buy.

Decked as a Bride...with a faded picture

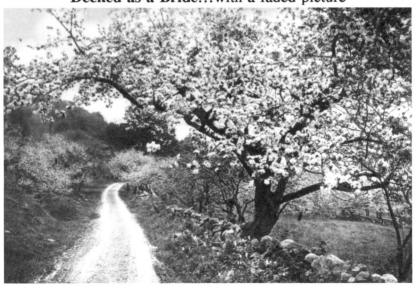

The Way Through the Orchard...with sharp color & detail.
The quality of the *picture* is extremely important.

Miscellaneous

Other things to look for in determining value are original wavy glass, original paper backing, and original copyright labels. These things are not absolutely necessary for an excellent picture, but they may represent the difference between an excellent picture and a mint condition piece.

Condition Guide

Poor/Fair Condition	Good/Excellent Condition
Picture	
Faded Coloring	Sharp Detail
Torn Picture	Very Nice Coloring
Poor Tinting	Almost Looks Like A Color Photograph
Mat	
Water Stains	No Stains or Spotting
Spotting	Original Coloring
Torn Mat	Sharp Indentation around
Yellowing	Picture
Frame	
Chipped	Original Brown Wood
Painted	No Chipped Paint or Pitting
Pitted	Tasteful, With Proper Proportions
Miscellaneous	
Dirt Under Glass	Original Copyright Label
Broken/Scratched Glass	Old Glass

The size of Wallace Nutting pictures can vary greatly.

Overall Size of Pictures

After analyzing the subject matter and condition of the picture, the third key to determining value is size. With only a few exceptions, the larger the picture, the greater the value. A larger Exterior is usually more valuable than a smaller Exterior; a larger Interior is usually more valuable than a smaller Interior.

There are two sizes to consider; the **picture size** and the **mat size**. Some people lend particular importance to the size of the picture itself, others do not. I personally feel that the mat size is the primary determinant of value because most collectors are concerned about how much wall space a picture will occupy. However, a disproportion between picture and mat could indicate that a mat has been cut down to eliminate water stains or other damage.

There are **two basic exceptions** to this *size* rule. The first has to do with *Miniatures*. These are small, framed pictures that first appeared in the 1930's. The frames are approximately 4"x5", the pictures 2"x3", and they frequently have a black border surrounding the pictures. These Miniatures are especially desirable to most collectors and command prices in the range of larger 7"x9" or 8"x10" pictures (see page 49).

The second exception may come as somewhat of a surprise. We have seen over the past several years at auction that the very large pictures, i.e., 20"x30", 20"x40", 30"x52", etc, just don't command a very high price. Although I would not consider these larger pictures rare, I would call them *unusual*. And, because they are unusual, and considering all the work that went into coloring them, you would expect that they would bring a value consistent with their scarcity.

To the contrary, we have seen that these large pictures seem to consistently bring prices comparable to a only 14"x17" picture.

The problem with larger pictures seems to lie in two areas: *Subject Matter* and *Size*. Nearly all large pictures I have seen are Exterior scenes, and common Exteriors at that: **The Swimming Pool, Slack Water, Water Maples, Flowering Time, Dream & Reality, Enticing Waters,** etc. As a result, relatively few people seem interested in making such a large, but common, picture the focal point of their collection.

The second problem has to do with size. Relatively few people today have sufficient wall space to accommodate such a large picture. Smaller pictures can be placed pretty much anywhere in an apartment or home but, if you don't have room for such a large picture, you can't hang it.

When you consider their relative rarity, and all the fine hand-work that went into each picture, I would think that such large pictures might be undervalued today. But based upon the prices we have consistently seen at auction, the demand just doesn't seem to be there for such large pictures.

In Summary:

* Exteriors are the most common pictures and are generally purchased by beginning collectors because of their lower price.

* Interiors are very desirable and are sought after by all levels of collectors.

* Unusual Topics are the most desirable and generally bring the highest prices from serious collectors.

* All pictures in good condition have value. In poor condition, even the rarest picture may have minimal value.

* With only a few exceptions, the larger the picture, the greater the value.

* Many items make up the overall picture: the picture itself, the matting, the frame, the glass, etc. A blemish to any of these tends to reduce the overall value.

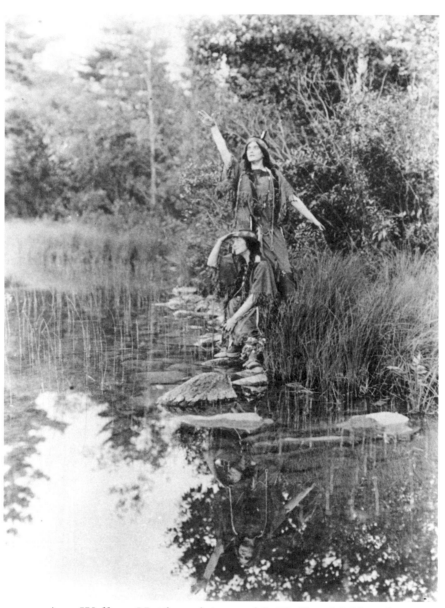

Any Wallace Nutting picture with "Indian Maidens"
is very unusual...and expensive. Est. Value: $1000 - $1500

Chapter 2

General Guide to Pricing Wallace Nutting Pictures

The following chart is a unique guide which provides a range of values that you might expect to **pay** for Wallace Nutting pictures. It provides some useful rules of thumb and can be a valuable aid in establishing an approximate value so that you don't pay too much or sell for too little. It is not meant to be an absolute statement of value and should not be taken as such.

Several further points should be considered.

> * These values are estimated **Retail** prices, i.e., what you might expect to fairly *pay* for a picture. If you are expecting to *sell* a picture, you can assume a dealer will pay somewhat less (usually 50% of the listed price).

> * The higher range should be reserved for pictures in excellent condition, i.e., those possessing most or all of the characteristics listed in the Good-Excellent Condition category on page 27.

> * The lower range is for pictures possessing only some of the characteristics listed in the Good to Excellent range. Pictures in Poor condition would generally fall *below* the lower range.

> * Although these prices are indicative of the current market, prices tend to fluctuate in different parts of the country. Prices may be higher or lower, depending on where you live.

The Pricing Guide may look complicated, but it's really easy to use.

For example:

The Daguerreotype, an Interior scene, 14"x17", in Excellent Condition (i.e., clean mat, nicely framed, excellent detail and coloring in the picture.) Go to the 14"x17" Interior Column, which shows a price range of $175-$375. Since all key characteristics are in excellent condition, the value would fall in the upper range of $275-$375. On the other hand if the picture had nice coloring and excellent detail but also a water stain and a chipped frame, the value would drop to the lower range, or $175-$275. A major water stain would drop the value below the $175 level.

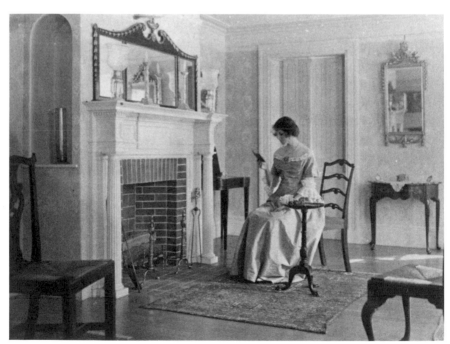

Wallace Nutting Price Guide to
Exterior and Interior Pictures

Mat Size	Exterior	Interior
4"x5"	$45-$80	$65-$125
5"x7"	$25-$50	$60-$110
7"x9"	$45-$75	$75-$125
7"x11"	$45-$85	$75-$135
8"x10"	$50-$85	$85-$145
8"x12"	$50-$85	$85-$150
10"x12"	$65-$95	$110-$175
11"x14"	$75-$150	$125-$250
11"x17"	$85-$175	$150-$275
13"x16"	$100-$225	$175-$350
14"x17"	$125-$225	$175-$375
13"x22"	$135-$235	$195-$395
15"x22"	$150-$250	$195-$425
18"x22"	$150-$250	$225-$475
22"x28"	$175-$275	$325-$575

Note: Pictures larger than 22"x28" are fairly unusual and difficult to locate. Logic would dictate that they would be more valuable than the smaller sizes. However, we have continually seen that they generally sell in the 22"x28" range. See page 29 for additional information on larger pictures.

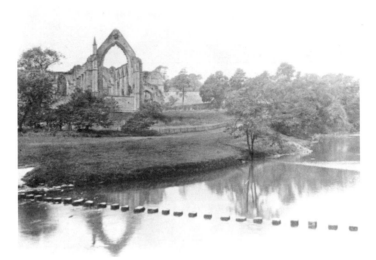

Stepping Stones at Bolton Abbey...
sold at auction for $352

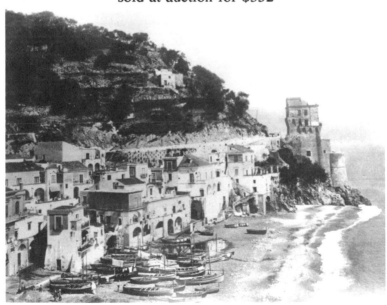

Cetera...sold at auction for $880

Pricing of Pictures in the Unusual Topic Category

The Price Guide on page 35 covers price ranges on Exterior and Interior pictures. As I mentioned earlier, however, the rarest Wallace Nutting pictures are those that fall under the Unusual Topic Category. They are also the most desirable for the serious collector. Comparatively few were made and most existing ones seem to be in private collections. As a result, few are readily available for sale today. *This is also the area that has seen the most dramatic price increases, and the area where all price records have been set.*

Pricing these is very difficult. Since there are increasingly fewer rare, top quality pictures readily available, demand has pushed prices much higher than they were just a few years ago. *A general rule of thumb is that, with only a few exceptions, a picture falling under the Unusual Topic Category is worth at least as much as a comparable Interior (i.e., same size and condition).* So, the starting point for valuing this category is the Interior Column on page 35.

Foreign Scenes

Although Wallace Nutting was best known for his New England Exterior pictures and Colonial Interior scenes, he also took pictures in 16 foreign countries during his three trips abroad (1904; 1915; and 1925), including:

Algeria	Ireland
Canada	Italy
Egypt	Palestine
England	Scotland
France	Spain
Germany	Switzerland

Greece	Syria
Holland	Turkey

Considering that he published two books on foreign countries (*England Beautiful* and *Ireland Beautiful*), it shouldn't be too surprising that you will find more pictures from these two countries than any other. Certain pictures from Holland and Italy were also good sellers for Nutting. Apparently during this 1910-1925 period, when the cost of a trans-Atlantic cruise was beyond the means of most people, and the day of commercial aviation had not yet arrived, one way people were able to fantasize about far-away lands was through books...and *pictures,* frequently Wallace Nutting pictures. Generally his best selling Foreign pictures were cottages, cathedrals, windmills, and other tranquil foreign settings.

As a result, titles like **Larkspur, A Garden of Larkspur, Hollyhock Cottage, Nethercote, Litchfield Minster, The Mills at the Turn,** and **The Pergola, Amalfi**, among others, were quite popular and many copies were sold. Therefore, they are generally easier to find today with prices falling below some of the other rarer Foreign scenes that you may find.

Overall I have seen very few pictures from the remaining countries listed above. Most of Nutting's pictures from the Mediterranean were taken very early in his picture-taking career, generally 1904 on his "Cruise of the 800" trip. Relatively few were sold commercially and quite frequently, pictures from these countries were never colored.

Somewhat surprisingly, few pictures from Canada will be found, despite the fact that he briefly opened a branch studio in Toronto in 1907. (It closed shortly thereafter because it proved to be unprofitable). The Canadian titles you may occasionally find will

be **A Nova Scotia Idyl, The Bay Road,** and **Evangeline Lane.** Rarely will you find other titles from Canada.

Because of the extremely wide range of titles within the **Foreign** category, pricing of these pictures has become increasingly complex. The more common titles should not be valued too high because they are relatively easy to locate. Those rarer titles in the best condition can command much stronger prices, as shown in the **Foreign** section of Chapter 8. You can refer to page 130 for a listing of recent Foreign picture prices.

Pictures with Animals

Overall, Wallace Nutting didn't sell many pictures with animals. Considering that much of America's population at this time was rural, it shouldn't be too surprising that people living in the country weren't too interested in having a picture of someone else's animals hanging upon their walls. Although they may have been somewhat more appealing to city dwellers, relatively few pictures with animals were sold.

Sheep although uncommon, are not rare. Certain titles such as **A Warm Spring Day, On the Slope,** and **Not One of the 400** offered a very tranquil, peaceful setting that proved to be very popular with the general public. Other sheep pictures did not sell as well back then and command considerably higher prices today.

According to scarcity and desirability to collectors, I would rank animal pictures as follows (from most common to most rare):

1) Sheep 4) Dogs
2) Cats 5) Horses
3) Cows

39

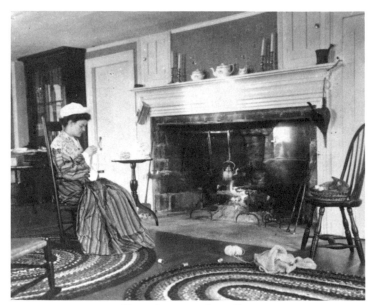

Comfort and a Cat

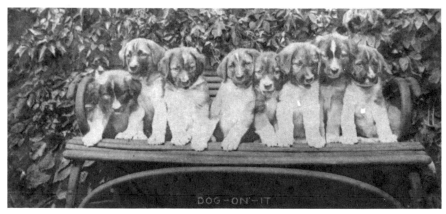

Dog-On-It

You can refer to page 138 for a listing of recent Animal picture prices.

Seascapes

These are uncommon and have become harder to locate as they have been assembled into private collections. Very few different seascapes scenes were actively marketed by Wallace Nutting, perhaps only 20-25. The most common titles you may see are **Sea Ledges, Swirling Seas,** and **A Maine Coast Sky.** See page 145 for a listing of recent Seascape prices.

Exteriors with People

Many of these are uncommon and generally quite desirable. Usually they involve people walking or sitting on porches. The most common titles seem to be **The Sallying of Sally, All in a Garden Fair,** and **The Going Forth of Betty.** A general rule is that most have the same value as a comparable Interior, although some may be worth up to 150%-250% more than a comparable Interior. Unfortunately, rarity determines value and it is difficult to be more specific in such a limited space. You will not go too far wrong by valuing such a picture as a comparable Interior. See page 147 for a listing which includes Exterior scenes with people.

Children

Pictures with Children are extremely desirable, generally quite rare, and every collector would love to have some in their collection. Just as rural residents were not interested in having pictures of someone else's animals hanging upon their walls, I

41

Flower Laden...an Exterior with a woman

The Coming Out of Rosa

think that most people were uninterested in hanging a picture of someone else's child in their home. As a result, although Nutting did actively try to market pictures with Children, they failed to sell in any significant numbers.

One exception to this rule about Children is "Rosa". One of Nutting's best selling pictures of all time was **The Coming Out of Rosa.** This picture, with a little girl standing upon a flower-covered front porch holding her mother's hand, was extremely popular and sold in large numbers. This picture still holds an attraction for collectors today, being voted as the most popular Wallace Nutting picture by collectors at the 1990 Wallace Nutting Collector's Club Convention. A picture titled **Posing**, with Rosa sitting in a child's chair on the porch beside her mother, was also very popular and sold well.

However, other pictures also containing Rosa (**The Going In of Rosa, Watching for Papa, Childhood Wiles, Rosa and a Bud,** and **Wavering Footsteps**) failed to sell in any considerable numbers and are considered rare today.

Considered to be the most highly sought-after **Child** picture by many collectors, **The Guardian Mother** sold at our April 1989 Auction for $4950.00, still the Auction Record for a Wallace Nutting picture. See page 140 for the listing of recent **Child** prices.

Floral Arrangements

As business was declining during the 1930 Depression years, Wallace Nutting was looking for other subject areas into which he could expand. In an attempt to cater to the growing Women's Gardening Club movement, one such area that he tested was Floral

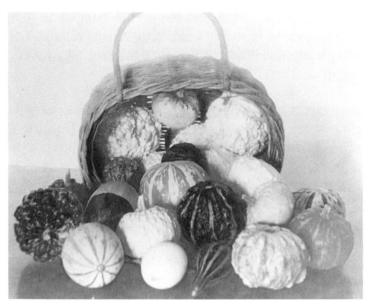

A Basket of Gourds sold at auction for $1100

The Easy Mark at Home sold at auction for $605

scenes. These were close-up pictures of vases or bowls of flowers, usually arranged by Mrs. Nutting. They are rare and don't look anything like a typical Wallace Nutting picture.

As Florals were all done in the 1930's, they are generally more brightly colored (since platinum paper was not used at this time), frequently have a black border surrounding the picture, and are commonly framed within a gold frame. It is also not uncommon to find the original copyright label on the back of these pictures.

There are approximately 25-30 different Floral scenes, and at one time they were even included in a special Floral Catalog that Wallace Nutting had produced to help sell these pictures. Sizes vary from Miniature 4"x5" to larger 16"x20" sizes. Floral scenes were frequently sold close-framed. However, with the Depression on at this time, relatively few were sold.

See page 142 for a listing of recent Floral sale prices.

Men

Although Nutting actively tried to market Interior scenes with Men, relatively few were sold. As a result, pictures including men are rare. Especially desirable are men in red jackets and "Uncle Sam" (an older man with an Uncle Sam-like beard). You will find relatively few untitled pictures with Men. Rather, most seem to be in the 13"x16" or 14"x17" sizes.

Pictures with Men have been bringing strong prices when in excellent condition. See page 143 for a listing on recent prices of pictures containing Men.

Snow Scenes

These are very rare and very desirable. The last thing New Englanders wanted to be reminded of was snow so therefore, very few snow scenes were purchased. As a result, they are quite rare today. Most snow scenes seem to be in the smaller 7"x9" - 8"x10" size and are untitled. If you are lucky enough to find a larger titled picture, congratulations. Within reason, you can name your own price.

See page 146 for a listing of recent prices of Snow pictures.

Miscellaneous

This is really a catch-all for pictures not already covered elsewhere. An experienced collector can identify an unusual picture immediately. Scenes from New York, Florida, Virginia, Pennsylvania, and California come to mind. Because these states were generally photographed much later than the New England states (i.e., New England, 1900-20; these other states usually after 1920), there were fewer productive years within which to sell pictures. Also the earlier pictures were sold within the peak period of hand-colored platinotype pictures; pictures from these other states were not introduced commercially until the popularity of hand-colored platinotypes began to decline. As a result, fewer pictures from these states were sold; hence, their rarity.

Depending on the topic, they may be valued anywhere from the base Exterior price to the upper limit for Unusual Topics. Only experience will dictate the accurate price.

In Summary:

* The better the condition, the higher the price you should expect to pay (or receive) for any given picture.

* It is usually very difficult to sell pictures in poor condition.

* Prices vary in different parts of the country.

* Pictures falling under the Unusual Topic Category are generally the most sought-after by serious collectors, and usually command the highest prices.

* When selling a picture, you can expect that a dealer will generally pay approximately 50% of the retail value.

This Untitled Snow scene sold for $473 at auction

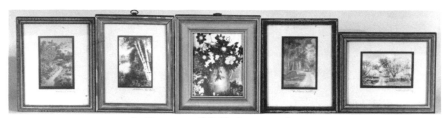

A Group of Miniature pictures

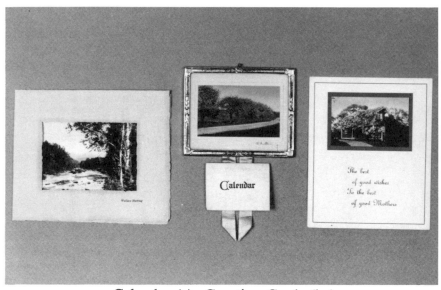

Calendar (c); Greeting Cards (l,r)

Chapter 3

Miscellaneous Topics

In addition to framed pictures, Wallace Nutting produced a series of related items. For lack of a better all-inclusive word, I'll call them Novelty Items.

Miniatures

As mentioned on page 29, Miniatures were small (2"x3"), matted pictures, approximately 4"x5" when framed. This was one of the smallest framed pictures that he produced and can actually be considered either a picture or a Novelty Item. These were generally hung in groupings and are highly prized by collectors. The price range for Miniatures can be found in the Price Guide on page 35.

The value of Miniatures is dependent upon both Condition and type of picture. Floral Miniatures have been generally bringing the highest prices, followed by Interior scenes, and then Exterior pictures. See page 143 for a listing of recent Miniature prices.

Calendars

Calendars were also generally quite small, coming in several different styles and sizes. One style was a hanging calendar. This consisted of a regular hand-tinted picture, approximately 3"x4", with the signature on the picture itself, and framed within a thin metal frame. The calendar portion hung below the picture, attached by a ribbon. Today most calendars have been removed. If you happen to find one with the calendar still attached, you have found a rarity.

49

A larger-style Calendar sold for $242 at auction

A second style was a free-standing calendar, approximately 4"x6". A small picture was positioned on the top and the calendar was attached to the bottom. At the end of each month, the previous month's page was discarded. Occasionally you may find calendars in somewhat larger sizes.

These were inexpensive items when originally produced (in 1915, calendars cost $2.75 each). Unlike the framed pictures, there was no real need to keep the calendar at the end of the year. Most were simply thrown away. As a result, few still exist today and, when available, seem to be priced around $100-$250 in Mint Condition.

See page 155 for a listing of recent Calendar prices.

Greeting Cards

Mother's Day Cards, Easter Cards, Friendship Cards, Christmas Cards and even a few Valentine's Day Cards were produced. Several different styles may be found:

* 4"x6", with a picture above a verse, single page
* 4"x6", with a picture above verse, folding tent style
* 5"x10", with a picture above a verse, single page
* Folding style with a picture inside
* Folding style with a picture on the front
* Folding Silhouette Mother's Day or Greeting Cards

After Greeting Cards were used, they were generally discarded. Unused cards have greater value than cards that have already been signed. Few still seem to be around, with prices also running around $75-$175, unframed, and in Mint Condition.

51

Miscellaneous Wallace Nutting Memorabilia

Not to be confused with "Miscellaneous Unusual Pictures", this is an **entirely new Category** of Wallace Nutting collectibles that has been added to this new 4th Edition. Specifically, this new Category covers anything that is **not** a standard hand-colored picture, book, Process Print, or Silhouette.

For example, this Category would include:

* Photographs of Wallace or Mrs. Nutting, photographs of the Wallace Nutting business, studio, colorists, or other photographs that convey a historical depiction of Wallace Nutting or his businesses.

* Letters or other Documents, either entirely hand-written by Wallace Nutting or typed and signed by him. Depending upon the actual historical content of the material, hand-written letters are generally more desirable than typed letters with only a Wallace Nutting signature.

* Picture Catalogs or Furniture Catalogs that relate to the Wallace Nutting business. (This Category would **not** include books that were actually authored by Wallace Nutting and published with the intention of mass distribution. Such books would fall under the **Book** Section).

* Wallace Nutting Studio Memorabilia consisting of items actually used within the Wallace Nutting studio, including such items as porcelain colorist's paint trays, colorist's paints and paint brushes, original colorist's coloring instructions, model pictures, glass negatives, colored and uncolored proof sheets, and anything else historically related to the Wallace Nutting picture business.

52

Provenance and Authenticity will become increasingly important with such items in the coming years. If you can document and prove that such items actually came from the Wallace Nutting studio, prices should become stronger than those similar items without such documentation.

* Miscellaneous sales materials, sales literature, advertising signs, and other Nutting advertising-related memorabilia

* Original magazine and newspaper articles actually written by Wallace Nutting over the years

* Also included in this **Miscellaneous** section would be Greeting Cards, Calendars, Postcards, Pirate Prints, and other things that may not neatly fit into any other Category

Although Silhouettes and Process Prints could have been placed here, I have given each their own Category to facilitate their identification.

In my opinion, many **Miscellaneous** items within this Category are still undervalued. Many of the items sold are one-of-a-kind items that cannot be found anywhere else...letters, glass negatives, colorist's instructions, items actually *used* by colorists... yet they sometimes sell for prices lower than the very common **Larkspur** or **The Swimming Pool**-type pictures...of which there are literally **hundreds** of similar pieces.

You should realize that when compared to many other areas of antique collecting, Wallace Nutting collecting is still in its infancy. Whereas people were actively collecting Currier & Ives in the 1920's and 1930's, Wallace Nutting collecting didn't really actively begin on a widespread basis until the 1980's. And even within the

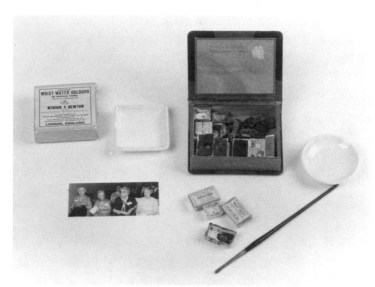

Winsor & Newton watercolors and a porcelain paint tray
actually used within the Wallace Nutting Studio

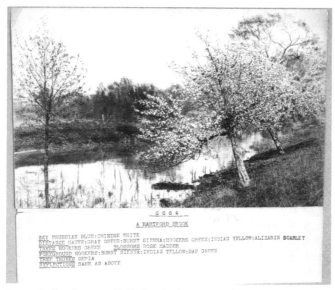

An original set of Colorist's Coloring Instructions

54

past 10 years, Wallace Nutting collecting is **still** evolving and being re-defined as more is learned. This new 4th Edition is evidence of how quickly things have evolved only since 1989.

A few advanced collectors have been squirreling some of these items away for later years, but, as I have already said, I definitely believe this is still one of the most undervalued areas of Wallace Nutting today. See page 155 for a listing of recent prices within the **Miscellaneous Wallace Nutting Memorabilia** Category.

Process Prints

During the 1930's Wallace Nutting began producing what he called Process Prints. These were **reprints** of some of his best-selling pictures and were **machine-produced** rather than hand-colored. This occurred during the Depression years in an attempt to bolster declining pictures sales. Process Prints are **not** considered reproductions because they were produced by Wallace Nutting and sold as such.

Identification of Process Prints is fairly simple:

　　* They consisted only of 12 titles:

1) A Barre Brook	7) Decked As a Bride
2) A Little River	8) Larkspur
3) A Sheltered Brook	9) Nethercote
4) All Sunshine	10) October Glories
5) Among October Birches	11) Primrose Cottage
6) Bonnie Dale	12) Red, White, & Blue

Process Prints...Note that there is no Wallace Nutting signature, and the title has been moved to the lower right corner

Authentic Wallace Nutting Process Pictures must bear this label. All others are unauthorized.

No. 2710

A **Process Print Label** appeared on the back of all Process Prints, but may have fallen off or been removed from many pictures

* All pictures were 12"x15". When mounted upon a mat, all mats measured 16"x20"

* Although some pictures contained copyrights upon the picture, none contained the Wallace Nutting signature on the matting. Rather, Nutting moved the title from the lower left corner of the picture to the lower right corner of the picture.

* Most Process Prints were identified by a Process Print Label on the back of the picture, but many of these labels have either fallen off or been removed.

These are not highly prized by most collectors. I have seen them priced from $5-$75 each. In reality, most collectors who are willing to spend a fair amount of money on a Wallace Nutting would prefer a hand-colored picture to a Process Print. I should point out that a supply of original Process Prints has appeared within the past year, thereby increasing their availability. Thus, their value is well below comparable hand-colored pictures. See page 159 for a listing of recent Process Print prices.

Silhouettes

In an attempt to improve sagging picture sales, Wallace Nutting introduced silhouettes around 1927. Drawn by his assistant, Ernest John Donnelly, more than 30 different silhouettes were introduced in 3 standard sizes, 4"x4", 5"x5", and 7"x8". With the crash of the stock market less than 2 years later, relatively few silhouettes were sold. Although not as pretty as the hand-colored pictures, they are still prized by collectors. Original backs with Wallace Nutting silhouette labels can add a premium of 10%-25% to the price.

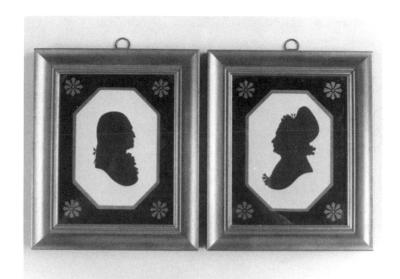

George and Martha Washington Silhouettes, with an original label on the back, sold for $132 at auction

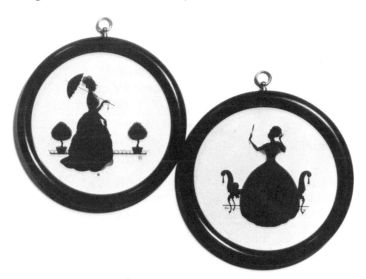

A pair of Silhouettes in more unusual round frames, sold for $110

You should understand that these silhouettes were **copies** of pentype silhouette drawings originally done by Ernest John Donnelly. Like Process Prints, each was machine-produced, not hand-done like the platinum prints.

You should also be aware that within the past year a quantity of original silhouettes has surfaced. All the ones I have seen are original, not reproductions, but the quantity available today seems to be greater than several years ago.

See page 160 for a listing of recent **Silhouette** prices.

Untitled Pictures

As we have already seen, Wallace Nutting pictures were produced in many different sizes. The medium and large pictures generally contained both the title and the Wallace Nutting name on the mat.

It was very difficult, however, to tastefully put both the title and signature on smaller pictures. It would have looked too crowded. As a result, the title was omitted and only the signature was added to pictures smaller than 10"x12". Some of these pictures contained the full *Wallace Nutting* signature; others used the abbreviated *W.Nutting* signature, and on small 5"x7"s only a *WN* was added.

As we have already discussed, large pictures are generally more desirable than smaller pictures and that definitely holds true regarding untitled pictures. *Collectors generally prize titled pictures more than untitled pictures.* Beginning collectors will frequently purchase untitled pictures because of their lower price. More serious collectors, on the other hand, will only purchase an untitled picture when they cannot obtain a larger version of the same picture.

See pages 118, 129, and 137 for recent prices of the various types of untitled pictures.

Pictures Framed Within Mirrors and Serving Trays

One of the most sought after items are Wallace Nutting pictures framed within mirrors. Specifically, these were framed mirrors with a Wallace Nutting picture (or pictures) mounted above, or alongside, the mirror itself. Some mirrors I have seen contain a signed and mounted picture; others contain only a signed or copyrighted picture, without the mat.

I have seen several mirrors with the name *Wallace Nutting* branded onto the back of the mirror. This would be a definite indication that the mirror was produced by Wallace Nutting. Most mirrors **do not** contain the branded signature, making it much more difficult to authenticate. These mirrors could have been produced by Wallace Nutting; they could have been framed and sold by a Department Store; or they could have been put together privately, either many years ago, or perhaps more recently.

Since few mirrors are readily available, prices are generally higher. Generally, the standard guidelines for pricing apply. Large mirrors of excellent quality, with the rarest pictures, command the highest prices. Smaller mirrors, with exterior scenes, in less than excellent condition, command proportionately lower prices. *Unless the mirror is specifically signed, you should probably assume it was **not** manufactured by Wallace Nutting.*

The same holds true for pictures framed within serving trays. Wallace Nutting as a rule did not produce serving trays. Like most mirrors, Wallace Nutting pictures framed within serving trays were

60

most likely put together by Department Stores or privately. *Unless the serving tray is specifically marked, you should probably assume that it was **not** manufactured by Wallace Nutting.*

Value should be guided by three things:

* Value of the picture itself

* Value of the mirror or serving tray itself

* Added value of the picture/mirror-serving tray combination

Start with the Price Guide on page 35 and add whatever additional premium value you feel the mirror or serving tray adds to the picture. In any event, if you have a mirror or serving tray with a great Wallace Nutting picture, you have a very desirable piece. If you want to buy one, expect to pay top dollar for it.

Types of Collectors

As in any other field of collecting, serious collectors value rare and unusual items more than the beginning collector. Therefore, they are willing to pay more for a special item for their own collection.

You should be aware that there are many different types of Wallace Nutting collectors. Some try to collect as many different pictures as they can find and afford, including Exteriors, Interiors, and Unusual Topics. Some collect only Interiors, while others collect strictly Exterior scenes.

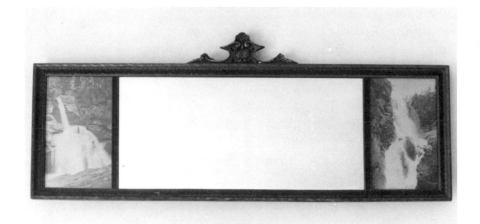

A vertical mirror with two Exterior scenes
sold at auction for $616.

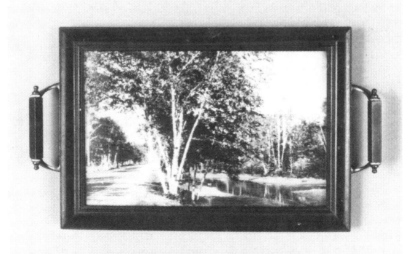

A Wallace Nutting Exterior scene,
framed within a serving tray...Est. Value: $125

Others specialize in a specific area:

Birch Trees
Ladies with Bonnets
Windsor Chairs
Clocks
Foreign Scenes, any Country
Foreign Scenes, specific Country only (e.g., only Italy)
Special States (eg.,Virginia, New Hampshire)
Sheep
Children

And these are only some of the areas of specialization. Some people collect only their special area. Others make their specialty the center of their collection, but still collect other types of Wallace Nuttings as well.

In any event, you should be aware that a Seascape is more valuable to a collector of Seascapes than to a general collector, just as an Italian picture is more valuable to a collector specializing in Italian Scenes.

Wallace Nutting Books

Another area we have added to this 4th Edition is a section on **books written by Wallace Nutting**. Although this doesn't technically fall under the Category of Wallace Nutting pictures, we decided to include it because of the large volume of inquiries we receive regarding Wallace Nutting books.

You can refer to page 162 for a listing of recent Wallace Nutting book prices.

Is it a real Wallace Nutting platinotype?...or a fake?

Chapter 4

Beware of Reproductions and Fakes

It happens in every field. As soon as something is successful and widely collectible, someone else tries to reproduce it. Wallace Nutting pictures are no exception. This chapter will cover **5 types** of reproductions and fakes that you should be on the lookout for.

Pirate Prints

The first series of reproductions occurred during the 1920's. One company literally purchased some Wallace Nutting pictures and reproduced copies of them on an offset press, leaving the title below the lower left corner of the picture, but omitting the Wallace Nutting name from the lower right corner. When Wallace Nutting first heard about this he supposedly said..."Why those Pirates...", hence the name, **Pirate Prints.**

Nutting fought them in court and won, but not until many had been reproduced. The quality was not good and they are quite easy to detect...*if you know what to look for.* The easiest way to identify these is with a magnifying glass. Because they were produced on an offset press, they will each have a series of little dots. An original hand-colored platinotype picture will **never** have a series of little dots. Instead, you should be able to see the brush strokes of the water colors that were hand-applied to the picture.

There are several ways to identify Pirate Prints from hand-colored pictures, but not all are 100% foolproof:

65

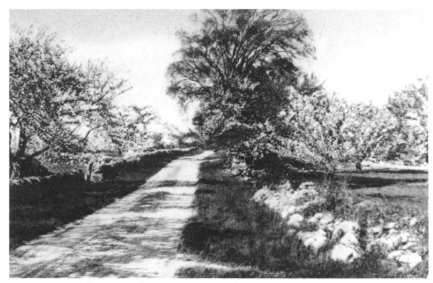

A Pirate Print. Note the title on the lower left, but the absence of any signature on the lower right

An example of a **fake** Wallace Nutting signature

* **A series of little dots will appear under a magnifying glass.** If these dots appear, it *cannot* be a hand-colored platinotype picture.

* **Although a title will appear below the lower left corner under the picture, there is no signature under the lower right side.** This is not fool-proof because some people have signed the Wallace Nutting name in the blank area with a comparably colored pen.

* **Most Pirate Prints have a border around the picture, generally a black border.** This is also not foolproof because some people have removed the black border and re-mounted the picture in order to make it appear more authentic. (Note: Remember that the black border by itself **does not mean** that the picture is a pirate print. Many authentic hand-colored pictures from the 1930's had a black border. See page 25).

* **Some Pirate Print titles include: The Swimming Pool, Honeymoon Stroll, A Grandpa and Grandma Bed, The Turf Path, Joy Path, and Honeymoon Blossoms,** among others.

Pirate Prints have no real value to collectors except as a piece of reference.

Non-Nutting Pictures With A Fake Wallace Nutting Signature

This form of thievery is becoming more common as the price of Wallace Nutting pictures continues to rise. Quite simply, some

people will buy any non-Wallace Nutting hand-colored picture, erase the name that is on it, and **re-sign it with** *"Wallace Nutting"*. Because these are hand-colored pictures, a magnifying glass will not reveal a series of little dots.

The problem with fake signatures is compounded because the *colorists*, **not** Wallace Nutting, signed the *Wallace Nutting name* to the matting. As a result, there is not one, but somewhere between 15-20 original Wallace Nutting signatures found on Wallace Nutting pictures.

Almost any experienced Wallace Nutting collector can identify a Wallace Nutting picture simply by *looking* at it. The picture coloring, the mat and picture size, the color and style of the mat, the type of picture, the copyright (or absence of one), the composition of the photograph, the quality of the picture contents (i.e., house, furniture, etc), the type of frame, etc, all have certain *"Wallace Nutting"* characteristics that become obvious to experienced collectors. But there are so many new collectors, and new dealers, with little Wallace Nutting experience, that they sometimes can't tell the difference between a real one and a fake. I receive several letters each month from people who have purchased such fake pictures.

These pictures have no value to Wallace Nutting collectors.

2nd Generation Reproductions - 1970's

A series of Wallace Nutting reproductions appeared in the late 1970's which were relatively hard to detect until you knew what to look for. These were initially sold by a store in Pennsylvania that specializes in selling antique reproductions of all types to the antique trade. Their business is legitimate because they tell you

68

exactly what they are selling...*reproductions*...for a fraction of the price of the real thing. Unfortunately, the people who buy things at this store all too often don't tell **their** customers that they are selling reproductions. As a result, many people get duped into thinking they are buying the real thing when in fact they are not.

This series of reproductions were all Interior scenes with titles including **A Chair for John, An Elaborate Dinner,** and **The Maple Sugar Cupboard.** Once you know what to look for, these are relatively easy to detect but, the first time you see them, you might be fooled. (I was once).

These reproductions have:

* a glossy picture with a dark tint

* A title and signature with a purple tint

* an almost paper thin mat

* a new frame

Note that these reproductions have a "glossy" picture. What this means is that these are actually 'photographs of a photograph', not offset-printed pictures. As a result, a magnifying glass **will not** show the series of small dots that can be seen with Pirate Prints or other machine-produced prints.

The new frame is not as good an indicator as before because many of these reproductions have been reframed with older frames and, those that haven't, now have frames with 10-15 years of aging on them. However, after you have seen a few of these reproductions, you will know what to look for. Fortunately, I've seen relatively few of these over the years but, occasionally they still do turn up.

A **1990** Wallace Nutting Calendar

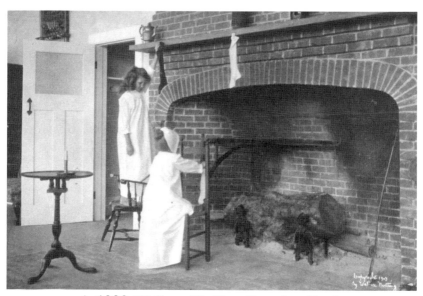

A **1990** Wallace Nutting Greeting Card

70

The value of these reproductions is minimal to Wallace Nutting collectors.

Fake Calendar and Greeting Card Pictures

Towards the end of 1989, a Wallace Nutting calendar was produced by a Member of the Wallace Nutting Collector's Club. This calendar was absolutely beautiful, with a different 4-color picture decorating each month of the year. A second calendar was released for 1991 as well, once again with a different picture for each month. The quality of this calendar was just as nice as the first.

Not surprisingly, some of these pictures have started to appear... cut out from the calendar...mounted upon a new (or sometimes old) matboard...with the title and Wallace Nutting name added...*and being sold as original hand-colored pictures.* Once you know what to look for, it becomes quite obvious. But, for those unsuspecting buyers, **The Guardian Mother** for $65 looks almost too good to pass up.

A series of 4-color Wallace Nutting Christmas and Greeting Cards were also introduced two years ago. If it hasn't started already, you can bet that someone will soon begin cutting these apart and marketing them as original Wallace Nutting pictures as well.

One good defense against these reproductions is knowing what they look like. Copies of the calendars, Christmas Cards, and Note Cards are still available from Diamond Press if you want to see what they look like.

Also, each of these items were produced on an offset printing press so each picture **will** show a series of little dots.

71

Latest Generation of Fakes - 1990's

This latest round of fakes are the best...and *worst*...series of reproductions yet. These are not simply reproductions being sold as reproductions. Rather, these pictures are down-and-out **fakes**...designed to **cheat** unsuspecting customers out of their money.

This series of fakes seems to have originated in New England and were most likely put together by someone fairly knowledgeable with Wallace Nutting pictures. To an experienced collector, this series of reproductions is also fairly easy to detect, but, as with each of the other groups of reproductions, inexperienced people will undoubtedly be fooled because the faker has gone to such great lengths to deceive unsuspecting customers.

* First, all pictures (I have seen about 10 different scenes) are glossy, brightly colored pictures. Most likely, they are photos of photographs. As a result, they **do not** show the small series of dots that will appear on machine-produced prints.
* None of the mats were indented
* All were framed with old frames (Which would indicate that this series of fakes is relatively limited. It's not easy to find hundreds of old frames in reasonably good condition. Newer frames would have implied a much broader fraud)
* All titles and signatures were in a new, dark ink
* All were freshly backed with new backing paper
* Each picture had a hand-cut, pre-printed, brown craft label on the back which stated the following: **This Picture is _____ by Wallace Nutting in Process Color**, with the WN Studio # being hand-stamped into the blank area.

72

* To add to the deception, some backs were hand-stamped with a fraudulent early date (i.e., Jun 21, 1926 and Mar 21, 1925)

To make matters worse, this individual went so far as to obtain a copy of **The Alphabetical and Numerical Index to Wallace Nutting Pictures** in order to obtain rare titles and their corresponding Studio #'s. For example, this thief found a legitimate Wallace Nutting title, **Tivoli**, which few, if any collectors had ever seen (thus making it more tempting since no one really knows what the real picture looked like). Then this individual took a non-Wallace Nutting picture that was obviously taken in Italy, reproduced it a few times, performed all of the above trickery and...presto...instant Wallace Nuttings.

Fortunately, this round of reproductions seems to have been quite limited, with most surfacing in New England. And as I said earlier, they are quite obvious and easy to spot...*once you know what to look for.*

What do these reproductions mean to Wallace Nutting collectors? Should you be concerned that reproductions will ruin the market? Absolutely not.

Since I've frequently described Wallace Nutting pictures as the Currier & Ives of the 20th century, let me use Currier & Ives pictures as a point of reference here. Reproductions of original Currier & Ives lithographs have been appearing for many years. In scouring flea markets for Wallace Nutting pictures, I've seen "re-strikes" of Currier & Ives, offset-printed reproductions of Currier & Ives, Insurance Company calendar pictures that have been cut-down and framed, greeting cards that have been reframed, pictures

from several books about Currier & Ives pictures that have been cut out and framed...*and still the Currier and Ives market is stronger than ever.*

The same holds true for Wallace Nutting pictures. Any knowledgeable collector can easily tell the difference between the real thing and a fake.

What is your best defense against fakes?

1) Be aware that there is a small group of Wallace Nutting reproductions and fakes just waiting to be purchased by some unsuspecting collectors. Too many people are now aware of the increasing value of Wallace Nutting pictures and are looking for a way to capitalize on it. Beware of any deal that looks **too** good. If the price appears ridiculously low, before reaching for your wallet... **ask yourself why?**

2) Become a knowledgeable collector. Read books, join the Wallace Nutting Collector's Club, read the Club Newsletter, attend the WNCC Annual Convention, or attend a Wallace Nutting Auction where you can see several hundred Wallace Nutting pictures all in one place.

3) When possible, buy from a knowledgeable and reputable dealer who specializes in Wallace Nutting pictures. Five years ago you could count the number of dealers who specialized in Wallace Nutting pictures on one hand. Today, there are several dozen. And the number is growing. These people know Wallace Nutting, and they know the difference between good, very good, and great Wallace Nutting pictures. They know them, they specialize in them, and they will guarantee what they sell.

4) Regardless of who you buy your Wallace Nutting pictures from...get a guarantee. Most antique dealers I know are hard working, honest, and underpaid individuals. They are dealing in antiques because they love antiques, not to make big bucks. Most could make more money doing something else if that's what they really wanted to do.

But at the same time, most antique dealers specialize in their own one or two areas of specialty, and **dabble** throughout the rest of the general line field. No dealer is an expert in everything. I know a great deal about Wallace Nutting pictures, and I know furniture pretty well, but I would have a hard time telling the difference between an original iron doorstop from a reproduction, or a piece of brilliant cut glass from a piece made in the orient last week.

Know what you are buying **before** you spend your money. Make certain that the dealer you are buying from is reputable and will guarantee what they sell.

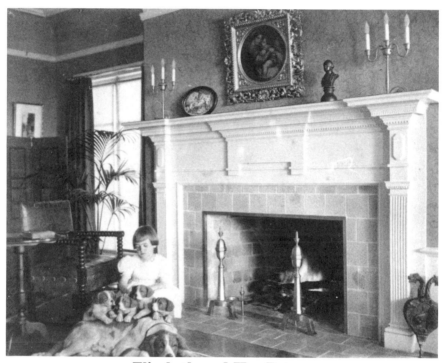

Elizabeth and Her Pets...
New pictures are **still** turning up.

Chapter 5

What's In The Future for Wallace Nutting Pictures?

In the past I have sometimes heard the comment that all Wallace Nutting pictures look alike. To the serious collector, nothing could be further from the truth.

Wallace Nutting pictures offer such a wide variety of topics, sizes, and areas of specialty that no two look alike. Since each was hand-colored, even the same picture with the same title and size can look different. You can literally spend years searching for these pictures and still find something you have never seen before.

Where will prices go as we approach the year 2000?

My personal feeling has always been that the price of Wallace Nutting pictures will follow the same pattern as Currier and Ives. Initially, Currier and Ives pictures were mass-produced, inexpensive, and readily available to everyone. (Phase I)

As they fell from style, few people wanted them. Since they were so inexpensive when originally purchased, many were damaged, destroyed or thrown away, and no one really cared. (Phase II)

Slowly, they came back into favor. Large numbers were still available and people started collecting them. Books were written about them, research was conducted, a Collectors Club was formed, and people became much more knowledgeable in the area. (Phase III)

Today, most Currier and Ives pictures are in private homes and collections. Common pictures bring top dollar, with medium folio

pictures, in average condition, usually bringing hundreds of dollars. Rarer large folio pictures in excellent condition bring **thousands of dollars,** with the best selling for **over $20,000.** And whenever a rare or special picture becomes available, it doesn't stay on the market long. (Phase IV)

Wallace Nutting pictures have just entered Phase IV. They have already achieved their initial widespread popularity where they were mass-produced, inexpensive, and available to everyone. (Phase I, 1900-1930's) They then went out of style (Phase II, 1930's-1960's).

Phase III has occurred over the past 20 years, as they were slowly assembled into personal collections.

We have now entered Phase IV. Good quality, rare pictures are no longer easily available. Collectors continually complain that they can't find good pictures anymore, and when they do, the quality is bad or the prices are too high.

Well, you had better get used to high prices, because the days of cheap Wallace Nutting pictures are over. 1988 saw the $1000 barrier broken on several pictures and 1989 saw the $5000 mark nearly broken. Wallace Nutting pictures are no longer cheap. But bargains are still around...if you look hard enough.

Traditionally antiques have been defined as things over 100 years old. The earliest copyright date I have seen on a Wallace Nutting picture is 1898. That means they are less than 10 years away from being technically termed as legitimate antiques. Things that are classified as "Collectibles" are valuable; things that are classified as "Antiques" are even more valuable.

Wallace Nutting pictures are on the threshold of Antiquity.

Chapter 6

A Collection of Some Rare and Unusual Wallace Nutting Pictures

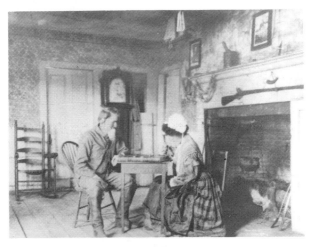

Two pictures from **Old New England Pictures...**
a book of pictures which sold at auction for $3080

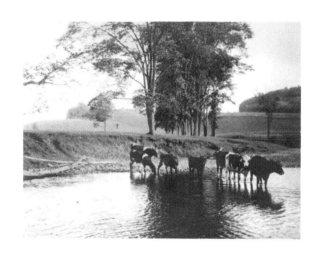

A 13"x16" Untitled Cow scene...sold at auction for $743

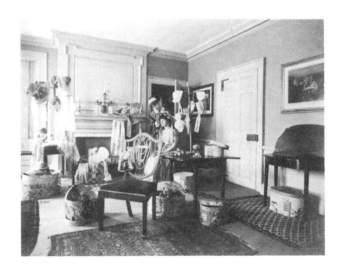

A Satisfied Customer...sold at auction for $468

A Pennsylvania College Portal...sold at auction for $440

3 Children in a carriage...sold at auction for $715

A Token for Easter...sold at auction for $363

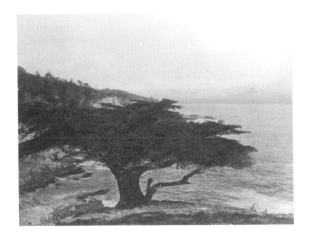

Cypress Heights...sold at auction for $715

Chapter 7

Summary Of Top Prices Reported In This 4th Edition

This new chapter is intended to provide you with a summary of some of the top prices that are reported in Chapter 8. I have a feeling that many people will be surprised at what they see. (Note that prices include the 10% Buyer's Premium, where applicable).

Top 25 Exterior Scenes

1)	The Face of the Falls	14x17	$440
2)	A Minnewaska Road	16x20	$352
3)	Purity and Grace	16x20	$341
4)	A Maine Farm Entrance	16x20	$286
5)	The Approach	11x14	$286
6)	A Brook in Doubt	14x17	$286
7)	Orchard Heights	16x20	$275
8)	An Orchard by the Hills	14x17	$253
9)	In Bright Array	15x18	$242
10)	Where the River Waits	15x22	$231
11)	The Stream of Peace	13x16	$231
12)	A Roadside Pine	14x17	$231
13)	Westfield Water	13x16	$226
14)	Dixville Shadows	15x18	$220
15)	Upper Winooski	11x17	$220
16)	Slack Water	15x22	$220
17)	The Heart of New England	13x20	$220
18)	Summer Wind	14x17	$220
19)	Stepping Heavenward	13x16	$220
20)	A Birch Mountain	18x22	$209

21) The Wealth of May	14x17	$209
22) Between the Spruces	16x20	$209
23) Summer Grotto	18x22	$209
24) Honeymoon Stroll	11x14	$198
25) The Swimming Pool	22x30	$187

Top 25 Interior Scenes

1) At the Spinnet	13x16	$625
2) Anxious to Please	12x14	$550
3) An Old Parlor Corner	14x17	$506
4) A Satisfied Customer	14x17	$468
5) A Virginia Reel	16x20	$425
6) An Informal Call	18x22	$425
7) An Old Time Romance	16x20	$425
8) Good Night	16x20	$425
9) Untitled Girl in Bedroom	11x14	$418
10) Announcing the Engagement	13x16	$413
11) At the Spinnet	13x16	$407
12) A Musical Reverie	14x17	$385
13) Fireside Contentment	14x17	$385
14) Is the Fire Ready?	14x17	$375
15) Very Satisfactory	16x20	$375
16) An Afternoon Tea	26x30	$374
17) Returning from a Walk	14x17	$374
18) A Virginia Reel	14x17	$363
19) Mending	18x22	$363
20) Tea in Yorktown Parlor	12x16	$352
21) A Comforting Cup	13x16	$350
22) A Cranford Tea Pouring	13x15	$330
23) A True D.A.R.	12x16	$330
24) An Inspiration	13x16	$330
25) In the Midst of Her China	14x17	$330

Top 25 Foreign Pictures

1) The Brook's Mouth	12x22	$990
2) Cetera	14x17	$880
3) Lorna Doone	14x17	$880
4) Rheinstein	12x15	$875
5) Swan Cove	20x28	$825
6) In Worden	10x16	$633
7) Gloucester Cloister	16x20	$663
8) The Expected Letter	11x14	$523
9) Dutch Sails	10x16	$473
10) The Old Mill, Amalfi	12x16	$473
11) Lincoln Gate	16x20	$462
12) Litchfield Minster	16x20	$462
13) The Sorrento-Amalfi Road	14x18	$440
14) A Dutch Bridge	11x14	$413
15) A Rug Pattern	12x16	$396
16) Litchfield Minster	14x17	$396
17) The Donjon	16x20	$385
18) Brook Paths	13x16	$375
19) Sailing Among Windmills	13x16	$375
20) Thatched Dormers	13x16	$375
21) Capri Bay	13x15	$358
22) On the Heights	9x15	$352
23) Stepping Stones at Bolton Abbey	18x22	$352
24) Vico Esquene	12x15	$350
25) Evangeline Lane	16x20	$341

Top 25 Miscellaneous Unusual Pictures

1) The Guardian Mother	12x16	$4950
2) The Meeting Place	18x22	$2750

3) The Guardian Mother	9x14	$2145
4) Off for the Legislature	13x16	$2035
5) Large Snow Scene	14x17	$1705
6) Priscilla Among the Heiffers	12x16	$1705
7) The Sunrise Call	14x17	$1595
8) Four O'Clock	14x17	$1430
9) Toward Slumberland	14x17	$1430
10) The Harvest Field	13x16	$1320
11) Dog-On-It	7x11	$1293
12) Pasture Dell	13x16	$1183
13) An Eventful Journey	14x17	$1155
14) A Village Coach	11x14	$1128
15) A Basket Running Over	16x20	$1100
16) Dog-On-It	7x11	$1100
17) Four O'Clock	14x17	$1100
18) A Patchwork Siesta	14x17	$1045
19) An Old Time Idyl	13x16	$1045
20) The Meeting Place	25x29	$1045
21) Arlington Hills	11x20	$1018
22) A Heart Chord	14x17	$990
23) An Old Tune Revived	13x16	$990
24) Cosmos and Larkspur	13x16	$963
25) La Jolla	7x11	$963

Top 25 Miscellaneous Items

1) 'Up at the Vilas Farm' Book	$3135
2) 'Old New England Pictures' Book	$3080

3) Nutting/Stickley Letter		$633
4) Group of 70 Unmounted B&W Glossy Pictures		$611
5) Colorist's Coloring Instructions		$550
6) Glass Wallace Nutting Sign		$550
7) Group of 10 Unmounted Colored Model Pictures		$550
8) Glass Wallace Nutting Sign		$525
9) Group of 10 Unmounted Colored Pictures		$523
10) Colorist's Coloring Instructions		$506
11) Wallace Nutting Letter		$468
12) Wallace Nutting Letter		$468
13) Group of 10 Unmounted Colored Pictures		$451
14) Group of 16 Unmounted Colored Pictures		$446
15) Triple-framed Grouping of Pictures		$440
16) Group of 7 Unmounted Colored Model Pictures		$404
17) Group of 10 Unmounted Colored Model Pictures		$385
18) 1908 Picture Catalog		$385
19) Group of 10 Unmounted Colored Model Pictures		$358
20) Group of 10 Unmounted B&W Glossy Pictures		$358
21) Page of 4 Nuttinghame Pictures		$330
22) Group of 10 Unmounted Colored Mounted Pictures		$330
23) 1908 Picture Catalog		$325
24) Group of 10 Unmounted Colored Model Pictures		$303
25) 1937 Furniture Catalog, Recovery Ed		$275

Top 50 Wallace Nutting Pictures/Items Overall

1)	The Guardian Mother	12x16	$4950
2)	'Up at the Vilas Farm' Book		$3135
3)	'Old New England Pictures' Book		$3080
4)	The Meeting Place	18x22	$2750
5)	The Guardian Mother	9x14	$2145
6)	Off for the Legislature	13x16	$2035
7)	Priscilla Among the Heifers	12x16	$1705
8)	Large Untitled Snow Scene	14x17	$1705
9)	The Sunrise Call	14x17	$1595
10)	Toward Slumberland	14x17	$1430
11)	Four O'Clock	14x17	$1430
12)	The Harvest Field	13x16	$1320
13)	Dog-On-It	7x11	$1293
14)	Pasture Dell	13x16	$1183
15)	An Eventful Journey	14x17	$1155
16)	A Village Coach	11x14	$1128
17)	Four O'Clock	14x17	$1100
18)	Dog-On-It	7x11	$1100
19)	A Basket Running Over	16x20	$1100
20)	The Meeting Place	25x29	$1045
21)	An Old Time Idyl	13x16	$1045
22)	A Patchwork Siesta	14x17	$1045
23)	Arlington Siesta	11x20	$1018
24)	The Brook's Mouth	12x22	$990
25)	An Old Tune Revived	13x16	$990
26)	A Heart Chord	14x17	$990
27)	La Jolla	14x17	$963
28)	Dog-On-It	7x11	$963
29)	Cosmos and Larkspur	13x16	$963
30)	Blowing Bubbles	5x9	$960
31)	Boys at Positano	13x16	$908
32)	A Dutch Knitting Lesson	10x14	$908

33) Lorna Doone	14x17	$880
34) Cetera	14x17	$880
35) Rheinstein	12x15	$875
36) Untitled Child	11x14	$853
37) Swan Cove	20x28	$825
38) Indian Maidens	12x15	$825
39) Drying Apples	14x17	$798
40) Mirror with 'Comfort and a Cat'	14x40	$770
41) Drying Apples	14x17	$770
42) A Little Helper	14x17	$750
43) Mirror with 'Skirmishing'	10x36	$743
44) Large Untitled Cow Picture	13x16	$743
45) Large Untitled Floral	11x17	$737
46) Untitled Children in Carriage	14x17	$715
47) Untitled Child	10x12	$715
48) The Way it Begins	12x14	$715
49) The Eventful Journey	14x17	$715
50) Cypress Heights	18x22	$715

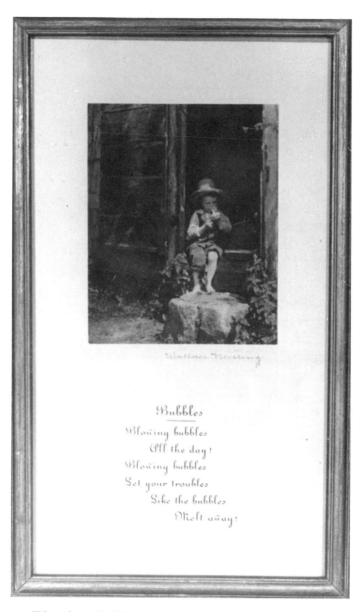

Bubbles

Blowing bubbles
All the day!
Blowing bubbles
Let your troubles
Like the bubbles
Melt away!

Blowing Bubbles...sold at auction for $960

Chapter 8

Listing of Recent Prices

As mentioned in the Introduction, the prices in this section are derived from many different sources, including:

* Michael Ivankovich Antiques Auctions
* Other Auction Houses from around the country
* Retail Sales
* Mail Order Sales
* Prices observed at antique shows and flea markets such as Brimfield, Farmington, and dozens of other such events
* Advertisements observed in numerous trade papers around the country
* Dealer Mailing Lists and Exhibitors at the Wallace Nutting Collector's Club Annual Convention
* Many private collectors and dealers who regularly report prices they have observed in their travels

Most prices here represent prices actually paid. In a few instances where I was unable to ascertain the final sale price, I have included the dealer asking price if I felt that it was appropriately priced and fell within the acceptable ranges.

Obviously not all titles are included here. However, I have tried to include as many titles and prices as possible in order to provide the broadest representative range of prices. Between all the sources listed above, I think that most titles will be included here. However, if a title you are looking for is not listed, you have two options:

1) Look for a comparable title. Since all titles were individually hand-written, there were occasional deviances from the actual title. For example, **An Afternoon Tea** became **Afternoon Tea, A Canopied Road** became **Canopied Road**, or **A Sip of Tea** became **The Sip of Tea.** If your isn't listed exactly, try looking under a comparable title.

2) If all else fails, refer to the Pricing Chart on page 35 and derive an approximate price using the pricing guidelines given in Chapter 2.

I should also clarify that there is no ironclad connection between the Pricing Guide in Chapter 2 and the Listing of Recent Prices that follows. The Pricing Guide is intended to show **how to set** an approximate value on a Wallace Nutting picture, while the Listing of Recent Prices reports values that **have already been set** by the marketplace by virtue of an actual Selling Price. You will notice that some prices do not follow the Pricing Guide. Some pictures were sold too cheaply; others sold much higher than their current value. Overall, however, you will find that most prices included in this section do correspond to the Pricing Chart.

One major improvement we have tried to address in this revised 4th edition is to provide some indication of the **condition** of the picture that was sold. As we have stressed earlier, **condition is the primary determinant of value.** In order to help you better relate the Selling Price to the actual condition of the picture, we have now added a special **Numerical Grading Code.**

This special **Numerical Grading Code** is something I have developed when cataloging pictures for our Wallace Nutting

Auctions. Every picture that is consigned to one of our sales is now assigned this **Special Numerical Grading Code** to help me estimate the approximate price that each picture might achieve.

This code is especially helpful to me when calculating Insurance values and when describing the picture over the telephone to our numerous absentee bidders. (However, at the suggestion of our auction attendees, I do not include this code in our Auction Catalog. Their feeling was that this subjective code could unduly influence bidding.)

Each picture listed in the section has been assigned a grading of 1-5, with 5 being the best, 1 being the worst. In order to arrive at the appropriate numerical grading, I have developed the following guidelines:

> **5...Excellent Condition.** These are pictures with absolutely no visible flaws. The picture has great color and detail, the mat is nice and clean with proper aging, and the frame is attractive and appropriate for the period.
>
> Only *titled* pictures can receive a "5". Smaller untitled pictures will generally not be graded a "5" because they are so typical and common.
>
> **4...Above Average Condition.** These are pictures that, although they may not have any visible flaws, just don't rate a "5". The picture has very good color and detail (but not great color and detail), the mat is nice and clean (but not quite a "5"), and the frame is totally acceptable.
>
> Occasionally, a "4" can be upgraded to a "5" with a better frame, or with a good cleaning on the inside of the glass.

The highest grading a smaller, untitled picture can receive is a **"4"** unless there is something especially unusual or distinctive about it.

In a few instances, an especially rare or unusual picture with a **minor** blemish (e.g., a small, faint water stain on the mat) might be rated a **"4"** if I feel that a picture is rare enough that it would be quite difficult to find another picture in better condition.

3...Average Condition. Although still attractive, these pictures have some visible flaw(s). Generally the flaw is with the mat and would include water stains, overmats, foxing, dirt under the glass, minor creases or tears, or other general blemishes. Re-mounted or Re-signed pictures would also fall into this category. Any mat blemish that can be completely covered with an overmat would be considered a **"3"**. Minor picture blemishes could also cause a picture to be graded a **"3"**. An example of a minor picture blemish would be a few small, white spots on the picture. Or, a damaged or unsightly frame could cause a picture to be graded a **"3"**.

A **"3"** picture that is very dirty or that has an unsightly frame can easily be upgraded to a **"4"** with a good cleaning or a new frame.

An overmatted picture can never be rated higher than **"3"**.

Pictures that have been either **re-mounted** or **re-signed** can never be rated higher than a **"3"**.

2...Poor Condition. Pictures falling within this category generally have **major** flaws or blemishes. Damage to the picture would include dark or faded coloring, noticeable tears or corner chips, or highly visible white spots. Mat damage would include things like large tears or creases, water stains that cover all or a portion of the title or signature, or other major damage that **cannot** be entirely covered with an overmat. Other examples of flaws that could cause a picture to be graded a "2" would be broken glass or a frame that is so damaged or unsightly that someone would probably not be interested in hanging a picture with such a frame.

Pictures that have broken glass or a horrible frame can be upgraded with the appropriate corrective action. Even an attractive picture with **major** mat damage might be upgraded to a "3" by re-mounting the picture. However, there is little that can be done to upgrade pictures with **major** picture damage.

1...Very Poor Condition. Quite frankly you very rarely see pictures with this grading because by the time they have reached this level, most have been trashed or thrown away. However occasionally they do turn up. Specifically, pictures that are rated "1" have irreparable damage to the picture itself. Specific examples would include pictures with major tears, pictures with unsightly spotting, pictures with ink spots, or other major damage making the picture unrepairable.

I can't think of any instance where a picture graded a "1" could be upgraded to a "2". In order to be graded a "1" the picture must be so bad that it is beyond repair.

I should remind you once again that this **Numerical Grading Code** is nothing more than my personal system for evaluating Wallace Nutting pictures. It is not perfect, and it is very subjective. However, I feel comfortable using it and believe that other Wallace Nutting experts would agree with my ratings in a majority of cases. In the absence of a better system, you are welcome to use it. And, if you find that you are able to make any improvements to it, I would appreciate hearing from you.

(Note that prices include the 10% Buyer's Premium, where applicable).

Exterior Scenes

A Barre Brook	10x16	Ext	$88	4
A Barre Brook	10x18	Ext	$66	4
A Barre Brook	11x17	Ext	$77	4
A Barre Brook	11X17	Ext	$55	4
A Barre Brook	12X20	Ext	$52	4
A Barre Brook	13X16	Ext	$22	3
A Barre Brook	13x16	Ext	$50	4
A Barre Brook	13x22	Ext	$94	4
A Barre Brook	14x17	Ext	$61	4
A Barre Brook	14X17	Ext	$116	5
A Barre Brook	14X17	Ext	$77	4
A Barre Brook	15x22	Ext	$61	4
A Barre Brook	15x22	Ext	$121	5
A Barre Brook	15x22	Ext	$83	3
A Barre Brook	16X20	Ext	$88	5
A Barre Brook	18x22	Ext	$77	4
A Barre Brook	18x22	Ext	$50	4
A Belle of the Olden Days	11x14	Ext	$55	4
A Belle of the Olden Days	11X14	Ext	$28	3
A Berkshire Brook	9x15	Ext	$61	4
A Berkshire Brook	10x16	Ext	$39	2
A Berkshire Brook	11x14	Ext	$72	4
A Berkshire Brook	12x15	Ext	$33	3
A Berkshire Brook	14X17	Ext	$110	4
A Berkshire Brook	14x17	Ext	$88	3

A Berkshire Brook	14X17	Ext	$41	3
A Berkshire Brook	14X17	Ext	$77	5
A Berkshire Brook	15X22	Ext	$83	4
A Berkshire Crossroad	14x17	Ext	$94	4
A Berkshire Crossroad	14x17	Ext	$50	3
A Berkshire Road	12x20	Ext	$72	5
A Berkshire Village	11x14	Ext	$66	3
A Birch Curve	13X15	Ext	$44	4
A Birch Grove	14x17	Ext	$72	3
A Birch Grove	18x22	Ext	$121	4
A Birch Mountain Road	18x22	Ext	$209	5
A Birch Paradise	12X16	Ext	$72	4
A Birch Paradise	14x17	Ext	$121	4
A Boy's Joy	13x16	Ext	$94	4
A Bridgewater Road	14x17	Ext	$154	5
A Brook in Doubt	14x17	Ext	$286	4
A Brook in Doubt	16x20	Ext	$77	5
A Burlington Glimpse	12x15	Ext	$154	4
A California Oak	14x17	Ext	$209	4
A Canopied Road	10x12	Ext	$25	2
A Canopied Road	10x12	Ext	$44	5
A Canopied Road	11X14	Ext	$39	4
A Canopied Road	12x15	Ext	$165	4
A Canopied Road	13X16	Ext	$66	5
A Canopied Road	20X28	Ext	$44	3
A Catskill Bank	13x16	Ext	$165	5
A Corner of the Field	10x12	Ext	$61	4
A Corner of the Field	14x17	Ext	$88	3
A Cove Landing	13x16	Ext	$110	5
A Decorated Bank	12X16	Ext	$83	4
A Disappearing Curve	14x17	Ext	$121	4
A Favorite Waterside	13x16	Ext	$61	3
A Fine Orchard	15x18	Ext	$88	5
A Finger Lake Stream	13x16	Ext	$94	5
A Forest Window	11X14	Ext	$105	5
A Framed River	13x16	Ext	$44	4
A Franconia Brook	9X11	Ext	$72	3
A Frangrant Highway	11X14	Ext	$55	4
A Hidden Cove	16x20	Ext	$88	4
A Highland Brae	12X15	Ext	$94	4
A Hint of September	24x28	Ext	$94	3
A Hurrying Brook	10x12	Ext	$50	4
A Lake Shore Oak	11x14	Ext	$55	4
A Lakeside Belvedere	13x16	Ext	$187	5

A Lane in Norwichtown	11x14	Ext	$55	3
A Lane in Norwichtown	11x14	Ext	$44	4
A Lane of Light	13x16	Ext	$88	5
A Leaf Strewn Brook	11x14	Ext	$99	4
A Leaf Strewn Brook	12X16	Ext	$50	5
A Leaf-Strewn Brook	13x16	Ext	$50	3
A Leaf Strewn Brook	13x16	Ext	$61	4
A Leaf Strewn Brook	13X17	Ext	$110	5
A Leaf Strewn Brook	14x17	Ext	$39	3
A Leaf Strewn Brook	14x17	Ext	$94	5
A Leaf Strewn Brook	16x20	Ext	$132	5
A Leaf-Strewn Brook	16x20	Ext	$88	4
A little Ford	14X17	Ext	$77	5
A Little Homestead	13x15	Ext	$66	3
A Little Homestead	12x18	Ext	$77	4
A Little River	9x11	Ext	$72	5
A Little River	10x12	Ext	$50	5
A Little River	10x16	Ext	$99	5
A Little River	11x14	Ext	$121	5
A Little River	11x17	Ext	$39	3
A Little River	11x17	Ext	$66	4
A Little River	11x17	Ext	$83	5
A Little River	12x18	Ext	$44	3
A Little River	13x22	Ext	$77	5
A Little River	16X22	Ext	$55	4
A Little River	20x26	Ext	$94	3
A Little River	20x30	Ext	$99	5
A Little River	20x40	Ext	$94	4
A Little River	20x40	Ext	$132	5
A Little River	22x30	Ext	$143	5
A Little River and Mt Wash.	12x20	Ext	$66	4
A Little River and Mt Wash.	15x22	Ext	$39	5
A Little River and Mt Wash.	16x20	Ext	$77	5
A Little River with Mt Wash.	11x17	Ext	$39	3
A Little River with Mt Wash.	11X17	Ext	$77	5
A Little River with Mt Wash.	12X20	Ext	$28	3
A Little River & Mt Wash.	10x16	Ext	$125	4
A Look Ahead	10x14	Ext	$55	4
A Maine Farm Entrance	16x20	Ext	$286	5
A Maple by the Stream	11x14	Ext	$94	4
A Maple by the Stream	11x14	Ext	$61	3
A Maple in May	14X17	Ext	$83	4
A Marlboro Roadside	13x16	Ext	$83	5
A Marlboro Roadside	12x16	Ext	$121	4

A Marlboro Shore	10x16	Ext	$55	4
A May Countryside	13x17	Ext	$52	4
A May Countryside	15x22	Ext	$72	5
A May Countryside	11x14	Ext	$94	4
A May Countryside	13X16	Ext	$88	5
A May Countryside, Mohawk Trail	13x15	Ext	$61	4
A May Drive	14x17	Ext	$61	3
A May Drive	10X16	Ext	$55	4
A May Drive	10x16	Ext	$55	3
A May Drive	11X17	Ext	$61	4
A Meadow Arch	9x11	Ext	$66	4
A Meadow Wedding	11x14	Ext	$39	4
A Minnewaska Road	16x20	Ext	$352	5
A Mountain Slope	11X14	Ext	$33	3
A Mystery Pool	12x15	Ext	$110	4
A New Hampshire Bridge	13x16	Ext	$143	5
A New Hampshire Road	10x16	Ext	$55	3
A New Hampshire Road	11x14	Ext	$72	4
A New Hampshire Roadside	14X17	Ext	$154	5
A New Hampshire Roadside	14x17	Ext	$44	3
A Newton Autumn	11x14	Ext	$44	4
A Pastoral Brook	11X17	Ext	$61	3
A Pasture Lane	12x16	Ext	$17	3
A Patriarch in Bloom	13x22	Ext	$99	4
A Patriarch in Bloom	15x22	Ext	$132	4
A Patriarch in Bloom	14X17	Ext	$83	5
A Patriarch in Bloom	20X40	Ext	$143	5
A Peep at the Hills	7x13	Ext	$66	4
A Peep at the Hills	10x16	Ext	$77	3
A Peep at the Hills	11x14	Ext	$66	4
A Peep at the Hills	11x17	Ext	$61	4
A Peep at the Hills	13x17	Ext	$83	4
A Pennsylvania Stream	13x16	Ext	$253	5
A Perkiomen October	6x9	Ext	$55	3
A Perkiomen October	16x20	Ext	$248	5
A Petaled Way	13x17	Ext	$61	3
A Pink Bower	11X14	Ext	$25	3
A Pittsfield Meadow	9x14	Ext	$88	4
A Plymouth Lane	11X17	Ext	$61	5
A Poet's Orchard	11x17	Ext	$55	4
A Poet's Orchard	11X17	Ext	$33	3
A Poet's Orchard	11x17	Ext	$41	3
A Pool of Delight	10x12	Ext	$135	5
A Rain of Gold	13x16	Ext	$99	5

A Rangeley Shore	9x11	Ext	$94	5
A Rangeley Shore	9X11	Ext	$66	5
A Riffle in the Stream	12x16	Ext	$28	3
A Riffle in the Stream	13x16	Ext	$127	5
A Rippling Brook	13x16	Ext	$105	4
A River in Maine	10x12	Ext	$55	4
A River in Maine	16X22	Ext	$28	3
A Roadside Apple Tree	16X20	Ext	$138	5
A Roadside Apple Tree	11x14	Ext	$121	4
A Roadside Brook	9x15	Ext	$44	3
A Roadside Pine	14x17	Ext	$231	5
A Rocky Dell	11x17	Ext	$44	4
A Sheltered Road	11x17	Ext	$55	5
A Sheltered Road	10x12	Ext	$135	5
A Silent Shore	13X17	Ext	$72	5
A Silver Screen	9x15	Ext	$41	4
A Sinuous Stream	13x16	Ext	$47	3
A Spring Pageant	11x17	Ext	$77	3
A Spring Pageant	11x14	Ext	$94	4
A Stamford Roadside	11x14	Ext	$150	5
A Stamford Roadside	10x12	Ext	$127	5
A Stamford Roadside	11x14	Ext	$50	5
A Stream of Peace	13x16	Ext	$187	5
A Summer Shore	11X14	Ext	$99	4
A Summer Stream	18x22	Ext	$66	3
A Sunkissed Way	11x14	Ext	$44	3
A Sunkissed Way	13x16	Ext	$66	1
A Sunlit Road	13x16	Ext	$55	3
A Trout Brook	16x20	Ext	$165	4
A Tunnel in Bloom	13x16	Ext	$105	5
A Tunnel of Bloom	11x14	Ext	$66	4
A Tunnel of Bloom	14x17	Ext	$143	4
A Vermont River	10x12	Ext	$55	4
A Vermont River	11x17	Ext	$72	3
A Vermont River	11X14	Ext	$44	3
A Vermont Road	18x22	Ext	$105	4
A Vermont Spring	10X12	Ext	$30	3
A Walpole Road	13X22	Ext	$72	4
A Watering Place	10x16	Ext	$77	5
A White Frame	11x14	Ext	$135	5
A Woodland Cathedral	13x16	Ext	$50	5
Above the Orchard	11X17	Ext	$61	4
Above the Orchard	11x17	Ext	$61	4
Accommodating Curves	13x17	Ext	$72	4

Across the Charles	16x20	Ext	$61	3
Across the Charles	20x40	Ext	$83	5
Across the Charles	12x16	Ext	$61	3
Across the Charles	11x14	Ext	$105	4
Across the Meadows	10x16	Ext	$116	3
Along Rock Creek	11x14	Ext	$121	5
Along the River	11x14	Ext	$55	4
Along the River	13x16	Ext	$61	5
An Alstead Stream	14x17	Ext	$72	5
An Alstead Stream	14x17	Ext	$55	5
An April Freshet	11x14	Ext	$50	4
An Auspicious Entrance	14x17	Ext	$55	4
An Autumn Shore	14x17	Ext	$72	5
An Obstructed Brook	13x16	Ext	$88	5
An Obstructed Brook	13X16	Ext	$66	5
An October Array	13x16	Ext	$55	5
An October Array	16x20	Ext	$165	5
An Old Back Door	11x14	Ext	$105	4
An Open Way	10X12	Ext	$61	4
An Orchard in the Hills	14x17	Ext	$253	5
An Overflowing Cup	14X17	Ext	$198	5
An Overflowing Cup	16x20	Ext	$88	4
An Overflowing Cup	9x11	Ext	$105	5
An Overflowing Cup	13x16	Ext	$28	2
Apple Blooms in May	10X16	Ext	$77	4
Apple Pool	16x20	Ext	$143	5
Apple Pool	9x11	Ext	$50	5
Apple Tree Bend	11X14	Ext	$25	4
Apple Tree Bend	10X12	Ext	$66	3
Apple Tree Bend	11x14	Ext	$50	3
Around the Pool	9X15	Ext	$61	4
At Danville	12x16	Ext	$116	4
At the Barway	18x22	Ext	$121	5
At the Hilltop	11x14	Ext	$58	3
August in the Meadow	10X17	Ext	$66	3
August in the Meadow	12x20	Ext	$83	4
Autumn Artistry	10x12	Ext	$55	5
Autumn Birches	11x17	Ext	$55	5
Autumn Delight	13x16	Ext	$187	5
Autumn Grotto	13x16	Ext	$88	5
Autumn Grotto	13x16	Ext	$77	4
Autumn Grotto	13x16	Ext	$55	3
Autumn in America	15x22	Ext	$105	5
Autumn Lights	10x12	Ext	$85	4

Autumn Nook	14x17	Ext	$77	3
Autumn Nook	13x16	Ext	$61	5
Autumn Ripples	10x12	Ext	$77	4
Autumn Ripples	10x12	Ext	$50	4
Autumn Waters	18x22	Ext	$94	3
Autumnal Peace	12x20	Ext	$105	5
Autumnal Peace	12x18	Ext	$77	3
Bars Down to Beauty	13x15	Ext	$99	4
Bethel Birches	10x12	Ext	$110	4
Between Birch & River	11x14	Ext	$72	4
Between the Spruces	16x20	Ext	$209	4
Between the Streams	11x14	Ext	$36	4
Billows of Blooms	12X15	Ext	$39	4
Billows of Blossoms	13x16	Ext	$72	4
Birch Bend	13x16	Ext	$77	3
Birch Bend	14X17	Ext	$72	5
Birch Brink	13x16	Ext	$83	5
Birch Brook	14x17	Ext	$94	5
Birch Drapery	13x16	Ext	$143	5
Birch Hilltop	11X14	Ext	$72	4
Birch Hilltop	11x14	Ext	$66	4
Birch Hilltop	12x20	Ext	$66	3
Birch Hilltop	13X17	Ext	$83	4
Birch Hilltop	13x17	Ext	$66	4
Birch Mountain Road	16x20	Ext	$99	5
Birch Strand	10x16	Ext	$83	4
Birch Strand	11x17	Ext	$88	4
Blooms at the Bend	11X14	Ext	$50	4
Blooms at the Bend	10x12	Ext	$39	3
Blossom Bordered	12X14	Ext	$44	3
Blossom Bordered	12x16	Ext	$55	4
Blossom Cottage	11x14	Ext	$132	4
Blossom Cove	12X16	Ext	$77	4
Blossom Cove	11x17	Ext	$77	4
Blossom Cove	13x22	Ext	$33	3
Blossom Cove	11X14	Ext	$25	2
Blossom Dale	12x16	Ext	$47	3
Blossom Drive	8X14	Ext	$61	5
Blossom Landing	10x16	Ext	$33	2
Blossom Landing	11X17	Ext	$66	3
Blossom Landing	13x16	Ext	$176	5
Blossom Landing	11x17	Ext	$61	5
Blossom Point	11x14	Ext	$66	3
Blossom Point	9x15	Ext	$83	4

Blossoms at the Bend	8X10	Ext	$72	4
Blossoms at the Bend	10x12	Ext	$44	4
Blossoms at the Bend	11X14	Ext	$55	4
Blossoms at the Bend	12x15	Ext	$44	3
Blossoms at the Bend	12x15	Ext	$94	4
Blossoms at the Bend	14X17	Ext	$66	4
Blossoms at the Bend	14x17	Ext	$132	5
Blossoms by the Lake	12X15	Ext	$94	4
Blossoms by the Lake	11x14	Ext	$77	4
Blossoms by the Lake	14x17	Ext	$99	5
Blossoms on the Housatonic	9x15	Ext	$99	3
Blossoms on the Housatonic	10x16	Ext	$72	4
Blossoms that Meet	11x14	Ext	$72	3
Bonnie May	12x20	Ext	$11	2
Bonnie May	14x17	Ext	$83	4
Bordering the Housatonic	11x14	Ext	$28	3
Bowered	14x17	Ext	$165	5
Boy's Delight	11x14	Ext	$94	4
Boy's Delight	11X14	Ext	$17	2
Brandon Arches	13x16	Ext	$66	4
Bride and Bridesmaids	16x20	Ext	$55	3
Bridesmaids Procession	13x22	Ext	$55	3
Broken Shadows	14x17	Ext	$66	4
Brook and Blossom	11x14	Ext	$55	3
Brook and Blossom	11x17	Ext	$44	4
Brook and Blossom	11x17	Ext	$55	4
Brook and Blossom	14X17	Ext	$143	4
Brook Borders	14x17	Ext	$66	4
Brookside Blooms	10x12	Ext	$41	4
Brookside Blooms	10x12	Ext	$55	4
Brookside Blooms	10x16	Ext	$39	5
Brookside Blooms	11X14	Ext	$28	3
Brookside Blooms	14X17	Ext	$187	5
Buck Hill Falls	13x16	Ext	$253	5
By the Meadow Gate	14x17	Ext	$77	4
By the Rangley Road	13x16	Ext	$94	5
By the Rangley Road	13x15	Ext	$55	3
By the Stone Fence	11x14	Ext	$22	3
By the Stone Fence	11x14	Ext	$72	4
By the Stone Wall	13x16	Ext	$33	3
California Hilltops	11x14	Ext	$132	4
Cathedral Brook	9x11	Ext	$72	4
Catskill Summit Blooms	14x17	Ext	$39	3
Charles River Elm	9x11	Ext	$99	5

Charles River Elm	16X20	Ext	$187	4
Cliff Pass	13x15	Ext	$154	4
Close-Framed Exterior	10x13	Ext	$39	3
Close-Framed Exterior	11x14	Ext	$138	3
Close-Framed Exterior	16X20	Ext	$105	5
Close-Framed Exterior	16x20	Ext	$165	5
Close-Framed Exterior	16x20	Ext	$121	4
Close-Framed Exterior	20x28	Ext	$71	5
Close-Framed Exterior	20x30	Ext	$99	4
Close-Framed Exterior	20x40	Ext	$94	4
Close-Framed °Red Eagle Lake'	16x20	Ext	$154	5
Close-Framed °Swimming Pool'	10x13	Ext	$39	3
Cobb's Creek Banks	10x13	Ext	$209	4
Cobb's Creek Banks	12x15	Ext	$110	3
Concord Birches	13x17	Ext	$50	4
Connecticut Blossoms	11x14	Ext	$88	4
Connecticut Blossoms	11x14	Ext	$61	4
Connecticut Blossoms	11x17	Ext	$88	4
Connecticut Blossoms	11x17	Ext	$110	4
Connecticut Blossoms	14x17	Ext	$44	3
Connecticut Blossoms	14x20	Ext	$25	3
Country Silence	13x16	Ext	$88	5
Cress Brook Road	13x16	Ext	$72	3
Cress Brook Road	14x17	Ext	$66	4
Decked as a Bride	11X14	Ext	$14	1
Decked as a Bride	11x14	Ext	$55	4
Decked as a Bride	11X14	Ext	$77	3
Decked as a Bride	11X14	Ext	$44	4
Decked as a Bride	13x16	Ext	$99	5
Decked as a Bride	13X16	Ext	$66	4
Decked as a Bride	13x16	Ext	$61	3
Decked as a Bride	14X17	Ext	$44	4
Decked as a Bride	14x17	Ext	$72	4
Decked as a Bride	14X17	Ext	$77	5
Decked as a Bride	14x17	Ext	$50	3
Decked as a Bride	16x20	Ext	$88	4
Decked as a Bride	16x20	Ext	$61	3
Decked as a Bride	16x20	Ext	$165	4
Delaware Water Lights	13x16	Ext	$220	4
Delaware Water Lights	10x13	Ext	$61	4
Dell Blossoms	12x14	Ext	$61	4
Dell Dale Road	10x12	Ext	$44	3
Dell Dale Road	26x36	Ext	$176	5
Dell Dale Road	13x16	Ext	$77	3

Disappearing in Blooms	13x17	Ext	$28	2
Dixville Shadows	10x12	Ext	$66	4
Dixville Shadows	13x16	Ext	$88	4
Dixville Shadows	15x18	Ext	$220	5
Dixville Shadows	16x20	Ext	$143	4
Dixville Shadows	16x20	Ext	$105	3
Down the Hill to School	13x15	Ext	$187	3
Dream and Reality	10X12	Ext	$28	2
Dream and Reality	10x12	Ext	$77	5
Dream and Reality	11x14	Ext	$83	4
Dream and Reality	11x14	Ext	$44	3
Dream and Reality	11x17	Ext	$61	2
Dream and Reality	12X16	Ext	$61	3
Dream and Reality	20x26	Ext	$121	4
Dream Birches	11x14	Ext	$50	4
Early June Brides	15x22	Ext	$66	4
Early May	15x22	Ext	$66	3
Early November	12x16	Ext	$61	3
Edgomoro	11x13	Ext	$99	4
Elm Curves	10X12	Ext	$19	3
Elm Drapery	14X22	Ext	$33	3
Elm Drapery	15x22	Ext	$66	4
Elm Drapery	13x17	Ext	$150	5
Enchantment	13X16	Ext	$22	3
Enticing Waters	9x11	Ext	$154	5
Enticing Waters	10x12	Ext	$66	3
Enticing Waters	11x14	Ext	$44	3
Enticing Waters	13x16	Ext	$105	4
Enticing Waters	14x17	Ext	$61	5
Enticing Waters	15x18	Ext	$22	2
Enticing Waters	15x19	Ext	$116	4
Enticing Waters	16X20	Ext	$176	5
Enticing Waters	18x22	Ext	$105	4
Enticing Waters	20x30	Ext	$99	5
Enticing Waters	26x30	Ext	$132	3
Fair Autumn	11X17	Ext	$33	4
Fair Woodstock	14x17	Ext	$165	4
Fairhaven Blossoms	12x15	Ext	$110	4
Fairhaven Blossoms	13x16	Ext	$39	3
Fairhaven Blossoms	11X14	Ext	$25	3
Fairway	12X16	Ext	$83	4
Fall Gowns	14X17	Ext	$61	5
Fall in the Berkshires	8x10	Ext	$55	4
Farm Borders	10x16	Ext	$77	5

105

Farm Borders	10x12	Ext	$44	4
Farm Borders	10X16	Ext	$110	5
Farm Borders	10x16	Ext	$28	2
Flower Bower	12X16	Ext	$94	5
Flowering Time	10x16	Ext	$66	4
Flowering Time	11x14	Ext	$66	4
Flowering Time	11x17	Ext	$50	4
Flowering Time	12X16	Ext	$14	1
Flowering Time	13x22	Ext	$61	3
Flowering Time	14x20	Ext	$61	4
Flowering Time	15x22	Ext	$44	3
Flowering Time	20x40	Ext	$94	4
Flush Banks	10x12	Ext	$61	3
Flush Banks	11x14	Ext	$39	3
Framed in White	8x10	Ext	$61	5
From Berkshire Crests	11x14	Ext	$176	5
From Berkshire Crests	13x16	Ext	$165	5
From Forest to Sunshine	15x22	Ext	$88	5
From the Mountain	10x16	Ext	$77	4
From the Mountain	11x17	Ext	$110	5
From the Mountain	11x17	Ext	$72	5
From the Mountains	11X17	Ext	$88	5
Golden Shores	14x17	Ext	$88	5
Golden Twilights	10x16	Ext	$11	3
Gorgeous May	10x12	Ext	$66	4
Gorgeous May	11x14	Ext	$77	4
Gorgeous May	11x14	Ext	$19	3
Gorgeous May	14x17	Ext	$55	5
Gorgeous May	16x20	Ext	$83	4
Gorgeous May	17x21	Ext	$83	5
Grace	10x12	Ext	$77	4
Grace	11X14	Ext	$105	4
Grace	11x14	Ext	$121	4
Grace	11x17	Ext	$66	5
Grace	13x16	Ext	$39	2
Grace	13x16	Ext	$145	4
Grace	14x17	Ext	$55	3
Grafton Windings	10x20	Ext	$39	3
Grafton Windings	12x20	Ext	$77	3
Grafton Windings	13x22	Ext	$66	3
Grafton Windings	13x22	Ext	$99	5
Grafton Windings	13x22	Ext	$145	4
Grafton Windings	15x22	Ext	$88	3
Half-Tide in October	10x12	Ext	$44	4

Honeymoon Stroll	10x12	Ext	$50	5
Honeymoon Stroll	10x12	Ext	$33	3
Honeymoon Stroll	11X14	Ext	$50	4
Honeymoon Stroll	11x14	Ext	$44	3
Honeymoon Stroll	11x14	Ext	$198	5
Honeymoon Stroll	13x15	Ext	$77	4
Honeymoon Stroll	13x16	Ext	$44	3
Honeymoon Stroll	14x17	Ext	$99	3
Honeymoon Stroll	14x17	Ext	$72	4
Honeymoon Stroll	15X22	Ext	$88	4
Honeymoon Stroll	16x20	Ext	$110	4
Honeymoon Windings	10x16	Ext	$61	4
Honeymoon Windings	10x16	Ext	$50	3
Honeymoon Windings	11x14	Ext	$28	5
Honeymoon Windings	11x14	Ext	$50	3
Honeymoon Windings	11x17	Ext	$39	3
Honeymoon Windings	11X17	Ext	$83	5
Honeymoon Windings	11x17	Ext	$55	5
Honeymoon Windings	12x15	Ext	$28	3
Honeymoon Windings	12x20	Ext	$77	3
Honeymoon Windings	14x17	Ext	$50	4
Honeymoon Windings	15x22	Ext	$50	3
Honeymoon Windings	20x40	Ext	$121	5
Hope	12X16	Ext	$138	5
Hope	11x14	Ext	$121	5
Housatonic Blossoms	10x16	Ext	$154	4
House Top and Hill Top	8x14	Ext	$88	4
Hurrying Water	10x12	Ext	$44	4
In Tenderleaf	7x13	Ext	$83	4
In Tenderleaf	10x12	Ext	$44	4
In Tenderleaf	11x14	Ext	$72	4
In Tenderleaf	11x17	Ext	$50	3
In Tenderleaf	11x17	Ext	$105	5
In Tenderleaf	13x17	Ext	$50	3
In Tenderleaf	13x22	Ext	$94	5
In Tenderleaf	14x17	Ext	$94	4
In Tenderleaf	15X22	Ext	$143	4
In Upland New England	13x16	Ext	$61	3
Into the Birchwood	10x12	Ext	$72	4
Into the Birchwood	10x12	Ext	$135	5
Into the Birchwood	11x14	Ext	$110	5
Into the Birchwood	13x16	Ext	$41	4
Into the Birchwood	14x17	Ext	$50	3
Into the Birchwood	20x26	Ext	$72	3

Into the Birchwood	20x30	Ext	$105	4
Into the West	9x15	Ext	$83	3
Into the West	8x15	Ext	$44	4
Jersey Blossoms	10x12	Ext	$55	3
Jersey Blossoms	10x12	Ext	$39	2
Jersey Blossoms	11x14	Ext	$72	4
Jersey Blossoms	11x14	Ext	$99	5
Jersey Blossoms	11x14	Ext	$110	4
Jersey Blossoms	11x14	Ext	$66	5
Jersey Blossoms	13x16	Ext	$50	4
Jersey Blossoms	14x17	Ext	$55	5
June Haze	11x17	Ext	$72	5
June Haze	12X18	Ext	$22	2
June Joy	13x17	Ext	$44	4
June Joy	11x14	Ext	$39	3
June Joys	14x17	Ext	$47	3
June Joys	11X14	Ext	$17	3
June Shadows	14x17	Ext	$55	4
Katahdin	16x20	Ext	$165	5
Lake Bank Birches	12X16	Ext	$39	3
Lane to Uncle Jonathan's	11x17	Ext	$143	5
Laneside	10x12	Ext	$36	3
Laneside	10x12	Ext	$44	4
Laneside	10x12	Ext	$61	4
Laneside	14x17	Ext	$66	4
Laneside	14X17	Ext	$44	4
Laughing Waters	14x17	Ext	$145	4
Lichen and Birch	10x12	Ext	$55	3
Lilac Cottage	10x16	Ext	$94	4
Lilac Cottage	11x15	Ext	$61	3
Lilac Cottage	10x16	Ext	$99	4
Lilac Cottage	10x16	Ext	$39	3
Lined With Petals	12x15	Ext	$110	3
Lined With Petals	11x14	Ext	$83	4
Lingering by the Rocks	16X20	Ext	$143	5
Lingering Water	15x22	Ext	$110	5
Lingering Water	10x12	Ext	$33	4
Lingering Water	10x14	Ext	$33	4
Lingering Water	11x14	Ext	$17	3
Lingering Water	11x14	Ext	$8	2
Lingering Water	11x17	Ext	$50	4
Lingering Water	11x17	Ext	$55	4
Lingering Water	13x16	Ext	$88	5
Lingering Water	8x10	Ext	$39	3

Lingering Waters	11x14	Ext	$110	4
Lingering Waters	11x14	Ext	$77	4
Lingering Waters	10x12	Ext	$44	4
Lingering Waters	13x16	Ext	$132	5
Luscious May	11x14	Ext	$55	4
Luscious May	14x17	Ext	$77	4
Luscious May	10X12	Ext	$41	4
Luscious May	13x16	Ext	$66	4
Many Happy Returns	11x14	Ext	$33	3
Many Happy Returns	11x14	Ext	$61	4
Many Happy Returns	10x12	Ext	$28	4
Many Happy Returns	11x14	Ext	$61	3
Maple Drive	10x12	Ext	$36	3
May Beautiful	14x17	Ext	$150	5
Meadow Blossoms	16x20	Ext	$105	5
Meadow Blossoms	11x14	Ext	$66	3
Meeting Branches	10x12	Ext	$44	3
Mohawk Trail Blossoms	10x12	Ext	$55	4
Mossy Logs	18x22	Ext	$176	3
Mossy Logs	16x20	Ext	$154	3
Mountain Born	10x16	Ext	$88	4
Mountain Born	10x12	Ext	$94	4
Mt Washington Ahead	11X14	Ext	$105	4
Nearing the Crest	9x15	Ext	$44	4
Neath Apple and Maple	14x17	Ext	$149	5
New England Birches	11x14	Ext	$88	2
New England Birches	11x14	Ext	$44	5
New Hampshire Birches	10X12	Ext	$22	3
New Hampshire Road	10x16	Ext	$66	4
New Hampshire Road	11x17	Ext	$77	3
October in May	10x12	Ext	$61	4
October in May	11x14	Ext	$83	4
October on the Charles	11X17	Ext	$94	5
October on the River	18x22	Ext	$99	4
October Splenders	12x16	Ext	$110	5
October Splenders	18x22	Ext	$94	5
October Splendors	13x16	Ext	$61	3
On Dress Parade	11x17	Ext	$55	5
On Dress Parade	13x16	Ext	$61	4
On Dress Parade	11X17	Ext	$61	4
On Dress Parade	10X16	Ext	$39	3
On the Ammonusac	13x16	Ext	$88	4
On the Quinnebaug	11x17	Ext	$116	5
On the Quinnebaug	13x16	Ext	$83	4

Orchard Heights	16x20	Ext	$275	5
Orchard Heights	18X22	Ext	$105	5
Orchard Shadows	13x16	Ext	$55	3
Orchard Shadows	16x20	Ext	$50	3
Orchard Shadows	10x12	Ext	$55	3
Over the Canal	12x16	Ext	$50	4
Over the Canal	10x16	Ext	$72	4
Over the Canal	10x16	Ext	$50	4
Over the Crest	12x16	Ext	$105	3
Over the Crest	11X17	Ext	$83	4
Over the Hills and Far Away	10X13	Ext	$55	4
Over the Lane	18x22	Ext	$61	4
Palms by the Pool	13x16	Ext	$275	5
Paradise Farm	10x12	Ext	$61	3
Pasture Birches	13x16	Ext	$50	5
Pasture Delights	11x14	Ext	$72	4
Petals Above and Below	10x12	Ext	$85	4
Petals Above and Below	10X12	Ext	$66	4
Petals Above and Below	11X14	Ext	$77	3
Petals Above and Below	11x14	Ext	$154	5
Petals Above and Below	8x10	Ext	$110	4
Petals in the Path	12x18	Ext	$25	2
Peterboro Triplets	16x20	Ext	$99	3
Pine Landing	10x12	Ext	$77	4
Pine Landing	10x12	Ext	$110	4
Pine Landing	10x16	Ext	$105	4
Pine Landing	11x14	Ext	$110	5
Pine Landing	12X21	Ext	$61	3
Pine Landing	13x16	Ext	$110	3
Pine Landing	14X17	Ext	$22	3
Pine Landing	16x20	Ext	$116	4
Pink, Blue, and Green	12X16	Ext	$33	3
Pitcher Pond	13x16	Ext	$50	3
Plymouth Curves	11x14	Ext	$61	4
Plymouth Curves	11x17	Ext	$66	4
Plymouth Curves	11x17	Ext	$44	3
Plymouth Curves	12X18	Ext	$121	5
Plymouth Curves	14x17	Ext	$61	3
Pomfret Waters	14X17	Ext	$187	5
Pomperaug Banks	10x16	Ext	$99	4
Purity	12x20	Ext	$77	4
Purity and Grace	16x20	Ext	$341	5
Purity and Grace	9X11	Ext	$66	4
Purity and Grace	16x20	Ext	$105	4

Queen of May	11x14	Ext	$99	4
Quivering Lights	10x12	Ext	$44	3
Red, White, and Blue	12X15	Ext	$88	4
Red, White, and Blue	13x16	Ext	$121	3
Red, White, and Blue	9x11	Ext	$88	5
Red Eagle Lake	13x16	Ext	$154	5
Respectable Old Age	11x14	Ext	$66	4
Rich Autumn	11x14	Ext	$83	4
Rippling in Silence	12x14	Ext	$33	3
Roadside Grace	10x16	Ext	$121	5
Roadside Grace	10x12	Ext	$28	3
Roanoke Sycamores	10x12	Ext	$50	3
Rock Creek Banks	10x12	Ext	$77	4
Rock Creek Banks	10x12	Ext	$165	5
Rock Creek in April	11x14	Ext	$94	5
Rock Creek in April	10x12	Ext	$83	4
Rural Joys	16x20	Ext	$94	5
Rural Sweetness	18x22	Ext	$121	4
Rural Sweetness	13x16	Ext	$55	3
Russet and Gold	13x16	Ext	$99	5
Russet and Gold	10x12	Ext	$50	3
Shadowy Orchard Curves	11X14	Ext	$105	5
Shadowy Orchard Curves	11x14	Ext	$121	5
Shadowy Orchard Curves	11x14	Ext	$88	4
Shadowy Orchard Curves	14x17	Ext	$77	3
Shadowy Orchard Curves	14x17	Ext	$150	5
Shimmering Cove	12x16	Ext	$72	4
Silver Birches	14x17	Ext	$66	3
Silver White	11x14	Ext	$39	3
Slack Water	8x12	Ext	$47	3
Slack Water	11X14	Ext	$55	3
Slack Water	15X22	Ext	$22	4
Slack Water	15X22	Ext	$220	5
Slack Water	20X28	Ext	$33	3
Slack Water	20x40	Ext	$116	5
Slack Water	28X46	Ext	$176	3
Soft Evening Lights	11x17	Ext	$50	2
Soft Evening Lights	12x14	Ext	$83	4
Spring Colors	11x14	Ext	$66	4
Spring Greens and Reds	13x15	Ext	$143	5
Spring Harmony	14x20	Ext	$72	4
Spring in the Dell	10x12	Ext	$11	2
Spring in the Dell	11x14	Ext	$72	4
Spring in the Dell	11x14	Ext	$33	3

111

Spring in the Dell	11x14	Ext	$50	3
Spring in the Dell	13X16	Ext	$55	4
Spring in the Dell	13x16	Ext	$83	4
Spring in the Dell	14x17	Ext	$61	5
Spring in the Dell	14x17	Ext	$55	3
Spring in the Dell	14x17	Ext	$143	4
Spring in the Dell	14x17	Ext	$61	4
Spring in the Dell	16x20	Ext	$154	5
Springfield Blossoms	13x16	Ext	$44	3
Springfield Blossoms	13x16	Ext	$72	4
Springfield Blossoms	13x16	Ext	$61	4
Springfield Blossoms	13x16	Ext	$105	5
Springfield Blossoms	14x17	Ext	$47	3
Stepping Heavenward	13x16	Ext	$209	5
Still Depths	11x14	Ext	$50	5
Still River	16x20	Ext	$72	3
Still Water	15x18	Ext	$94	4
Stony Brook Drive	13x16	Ext	$110	4
Summer Clouds	11x14	Ext	$39	3
Summer Grotto	18x22	Ext	$209	4
Summer Grotto	14x17	Ext	$187	5
Summer Wind	10x12	Ext	$50	4
Summer Wind	10x12	Ext	$110	4
Summer Wind	10x16	Ext	$72	5
Summer Wind	12x16	Ext	$50	4
Summer Wind	13x22	Ext	$61	3
Summer Wind	14x17	Ext	$220	4
Summer Wind	18x22	Ext	$143	4
Sunset Calm	11x17	Ext	$94	5
Sylvan Dell	12x20	Ext	$72	4
Sylvan Dell	10x20	Ext	$110	4
Sylvan Dell	11X17	Ext	$50	4
Tail Race and Bridge	14x17	Ext	$145	5
The Apple Over the Brook	11X17	Ext	$55	3
The Apple Over the Brook	11x17	Ext	$138	5
The Apple Tree by the Stream	11x14	Ext	$55	3
The Apple Tree by the Stream	10X12	Ext	$39	4
The Apple Tree by the Stream	14x17	Ext	$55	4
The Apple Tree by the Stream	14x17	Ext	$72	5
The Approach	11x14	Ext	$286	5
The Ash Row	18x22	Ext	$88	3
The Ash Row	18X22	Ext	$88	3
The Beautiful Perkiomen	13x16	Ext	$220	4
The Beauty of the Uplands	13x22	Ext	$61	3

The Beauty of the Uplands	10X18	Ext	$22	2
The Beckoning Road	13X22	Ext	$99	5
The Bee's Paradise	11x17	Ext	$66	4
The Birch Curve	13x16	Ext	$55	3
The Bridesmaids of the Woods	13x16	Ext	$176	5
The Bridesmaid's Procession	10x12	Ext	$39	3
The Bridesmaid's Procession	10x16	Ext	$39	3
The Bridesmaid's Procession	11x14	Ext	$88	5
The Bridesmaid's Procession	11x17	Ext	$135	4
The Bridesmaid's Procession	12x20	Ext	$77	4
The Bridesmaid's Procession	13x22	Ext	$39	3
The Bridesmaid's Procession	14X20	Ext	$61	3
The Call of the Road	13x16	Ext	$50	3
The Call of the Road	13x16	Ext	$83	5
The Call of the Road	14X17	Ext	$66	5
The Call of the Road	10x12	Ext	$19	2
The Charles in October	13x17	Ext	$94	5
The Coming Out Season	11x14	Ext	$39	3
The Connecticut Roadside	14x17	Ext	$154	3
The Crossroads in May	11X14	Ext	$105	3
The Curve	11x17	Ext	$121	4
The Equinox Pond	15x22	Ext	$88	3
The Equinox Pond	13x22	Ext	$61	2
The Face of the Falls	14x17	Ext	$440	5
The Fairlee Mirror	11x14	Ext	$110	4
The Farm Bridge	14x17	Ext	$132	4
The Farm Causeway	10x12	Ext	$72	4
The Gemmed Lake	8x12	Ext	$99	4
The Golden West	10x12	Ext	$50	4
The Grace of the Elms	11x14	Ext	$50	4
The Graces	14x17	Ext	$145	5
The Great Wayside Oak	10X12	Ext	$72	4
The Great Wayside Oak	10x12	Ext	$50	3
The Great Wayside Oak	11x14	Ext	$105	5
The Great Wayside Oak	13x16	Ext	$143	5
The Great Wayside Oak	14x17	Ext	$66	3
The Great Wayside Oak	14x17	Ext	$154	5
The Great Wayside Oak	20x26	Ext	$105	3
The Green Mountain Range	15x22	Ext	$72	5
The Green Mountain Range	11x17	Ext	$88	4
The Green Mountain Range	11x17	Ext	$66	4
The Green Mountain Range	12x16	Ext	$44	3
The Heart of New England	13x20	Ext	$220	5
The Heart of the Hill	16x20	Ext	$176	4

The Hill Oak Road	14x17	Ext	$121	3
The Home Field	9x16	Ext	$187	5
The Hope of the Year	14x17	Ext	$33	4
The Jefferson Hills in June	14x17	Ext	$50	3
The Lane in April	13x16	Ext	$66	4
The Light Side of the Road	12x15	Ext	$61	5
The Light Side of the Road	9x15	Ext	$50	4
The Lure of Home	11x14	Ext	$165	4
The Manchester Battenkill	16x20	Ext	$198	5
The Meeting of the Ways	10x12	Ext	$61	4
The Meeting of the Ways	10X12	Ext	$44	4
The Meeting of the Ways	11X14	Ext	$44	3
The Meeting of the Ways	11X14	Ext	$28	2
The Meeting of the Ways	11X14	Ext	$66	2
The Meeting of the Ways	12X16	Ext	$61	5
The Meeting of the Ways	13x16	Ext	$66	3
The Nashua Asleep	9x11	Ext	$154	4
The Nashua Asleep	13x16	Ext	$66	5
The Natural Bridge	14x17	Ext	$39	3
The Opening Year	10x12	Ext	$125	5
The Orchard Bend	11x14	Ext	$33	3
The Orchard Bend	12X14	Ext	$22	2
The Orchard Brook	18x22	Ext	$127	5
The Orchard Brook	11x14	Ext	$77	4
The Orchard Brook	11x14	Ext	$88	5
The Pine by the Cleft	18x22	Ext	$99	3
The Pine Meadow	14x17	Ext	$143	5
The Pool	10x12	Ext	$72	4
The Pool	10x12	Ext	$55	5
The Pool	10x12	Ext	$72	4
The Pride of the Lane	14x16	Ext	$72	5
The Pride of the Lane	14x17	Ext	$105	3
The Pride of the Lane	14x17	Ext	$72	4
The Purling River	14x17	Ext	$165	4
The Quintet	10X18	Ext	$88	4
The Road to Far Away	12x16	Ext	$94	4
The Shaken Mirror	13x16	Ext	$50	4
The Silent Shore	13X16	Ext	$50	3
The Silent Shore	11X14	Ext	$25	3
The Silent Shore	16x20	Ext	$121	4
The Softness of Spring	16x20	Ext	$44	3
The Softness of Spring	14x17	Ext	$77	5
The Softness of Spring	13x15	Ext	$61	3
The Sough of the Pines	13x15	Ext	$154	5

The Stream of Peace	11x14	Ext	$47	3
The Stream of Peace	18x22	Ext	$99	5
The Stream of Peace	13x16	Ext	$231	5
The Sweets of Spring	13x15	Ext	$77	3
The Swimming Pool	10x12	Ext	$72	4
The Swimming Pool	10x12	Ext	$61	4
The Swimming Pool	10x13	Ext	$77	4
The Swimming Pool	10x16	Ext	$72	4
The Swimming Pool	10X16	Ext	$66	4
The Swimming Pool	11x14	Ext	$44	4
The Swimming Pool	11X14	Ext	$50	3
The Swimming Pool	11x14	Ext	$72	4
The Swimming Pool	12x20	Ext	$83	5
The Swimming Pool	12x20	Ext	$50	5
The Swimming Pool	13x15	Ext	$55	5
The Swimming Pool	13x16	Ext	$77	5
The Swimming Pool	13x16	Ext	$61	4
The Swimming Pool	13x17	Ext	$44	5
The Swimming Pool	13x17	Ext	$50	4
The Swimming Pool	14x17	Ext	$55	3
The Swimming Pool	14x17	Ext	$61	5
The Swimming Pool	14X17	Ext	$50	5
The Swimming Pool	15x18	Ext	$83	5
The Swimming Pool	15x22	Ext	$61	4
The Swimming Pool	16x20	Ext	$44	2
The Swimming Pool	16x20	Ext	$61	3
The Swimming Pool	16x20	Ext	$33	3
The Swimming Pool	16X22	Ext	$50	3
The Swimming Pool	18X22	Ext	$17	3
The Swimming Pool	20x30	Ext	$94	4
The Swimming Pool	20x40	Ext	$110	4
The Swimming Pool	20x40	Ext	$88	4
The Swimming Pool	22x28	Ext	$77	3
The Swimming Pool	22x28	Ext	$94	3
The Swimming Pool	22x30	Ext	$187	5
The Swimming Pool	26x30	Ext	$176	4
The Swimming Pool	26X30	Ext	$110	4
The Tracery of May	12x15	Ext	$83	4
The Trout Brook	12x16	Ext	$61	3
The Turn by the Bars	13x17	Ext	$83	3
The Turn Homeward	14X17	Ext	$110	5
The Unbroken Flow	13x22	Ext	$83	4
The Vilas George	11x14	Ext	$110	4
The Walpole Road	11x17	Ext	$39	4

The Way Through the Orchard	10x12	Ext	$33	4
The Way Through the Orchard	11x14	Ext	$55	5
The Way Through the Orchard	11X14	Ext	$72	4
The Way Through the Orchard	12x20	Ext	$47	3
The Way Through the Orchard	13x16	Ext	$55	3
The Way Through the Orchard	14X17	Ext	$33	4
The Way Through the Orchard	16x20	Ext	$88	5
The Way Through the Orchard	18x22	Ext	$77	5
The Wealth of May	14x17	Ext	$209	5
The World Beautiful	10x16	Ext	$61	5
The World Beautiful	11X17	Ext	$11	1
The World Beautiful	14X17	Ext	$77	5
The Youth of the Saco	13x16	Ext	$187	5
Through the Orchard	13X16	Ext	$99	5
Through the Orchard	10x12	Ext	$135	5
Through the Orchard	13x16	Ext	$105	5
Toward Purple Hills	11x14	Ext	$50	3
Toward the Mountains	12X14	Ext	$25	4
Triplets	10x12	Ext	$61	4
Truant's Dell	11x17	Ext	$94	5
Twin Sentinels	14x17	Ext	$88	5
Twin Sentinels	11x14	Ext	$39	3
Under Blossom Bowers	10x13	Ext	$61	5
Under the Elm	10x12	Ext	$50	3
Under the Pine	11x17	Ext	$143	4
Unruffled	10x16	Ext	$61	4
Unruffled	11X17	Ext	$77	4
Upper Winooski	11x17	Ext	$220	5
Upper Winooski	14x17	Ext	$99	5
Upper Winooski	10x16	Ext	$165	5
Wachusett Blooms	11x14	Ext	$50	3
Walk Under the Buttonwoods	14x17	Ext	$154	5
Walk Under the Buttonwoods	13x16	Ext	$77	4
Water Maples	14x17	Ext	$61	3
Water Maples	14x17	Ext	$88	3
Water Maples	16x20	Ext	$88	3
Water Maples	16x20	Ext	$110	3
Water Maples	26x32	Ext	$110	3
Water Maples	26x38	Ext	$94	3
Water Tracery	14x17	Ext	$99	5
Water Tracery	13x16	Ext	$83	4
Water Witchery	13x15	Ext	$99	5
Watersmeet	11x14	Ext	$61	4
Watersmeet	13x16	Ext	$28	2

Watersmeet	13x16	Ext	$66	3
Watersmeet	14x17	Ext	$77	5
Watersmeet	14x17	Ext	$94	4
Watersmeet	14X17	Ext	$66	4
Watersmeet	18x22	Ext	$187	4
Watersmeet	26X30	Ext	$44	4
Westfield Water	11x17	Ext	$83	4
Westfield Water	14x17	Ext	$61	3
Westfield Water	13x16	Ext	$226	5
Westfield Water	12x20	Ext	$105	5
Westmore Drive	8x10	Ext	$39	4
Westmore Drive	10x18	Ext	$116	4
Westmore Drive	10X20	Ext	$50	3
Westmore Drive	11x14	Ext	$50	5
Westmore Drive	14X17	Ext	$83	4
Westmore Drive	16x20	Ext	$66	5
Where Bees Are Humming	13x17	Ext	$121	4
Where the River Waits	11x17	Ext	$94	4
Where the River Waits	15X22	Ext	$231	5
Where the Road Turns	9X22	Ext	$88	4
Where Trout Lie	13x16	Ext	$105	5
Wild Apple and Birch	11x14	Ext	$44	4
Windsor Blossoms	14X17	Ext	$99	4
Windsor Blossoms	13x16	Ext	$44	4
Windsor Blossoms	14x17	Ext	$88	5
Winslow Water	14X17	Ext	$121	4
Wissahickon Blossoms	13x15	Ext	$55	3
Wissahickon Blossoms	10X12	Ext	$121	4
Wissahickon Decorations	13x16	Ext	$187	4
Witch Water	12x16	Ext	$110	4

Untitled Exterior Pictures

Wallace Nutting Untitled Exterior scenes generally consisted of smaller pastoral views, with mat sizes ranging from 5"x7" - 10"x12". In most instances, Untitled Exteriors were smaller versions of Nutting's more popular and best-selling outdoor pictures. Typical scenes included apple blossoms, orchards, country lanes, birches, stone walls, ponds, lakes, and streams. Most Untitled Exterior scenes are fairly common.

Of the Untitled Exterior pictures we reviewed, most followed these pricing patterns:

Mat Size	Price Range	Average Price
5"x7"	$15 - $80	$35
7"x9"	$20 - $80	$45
7"x11"	$20 - $95	$60
8"x10"	$20 - $95	$50
8"x12"	$20 - $95	$65
10"x12"	$30 - $125	$75

(If your picture does not match exactly with the above sizes, go to the next nearest size)

Interior Scenes

A Bit of Sewing	10x12	Int	$94	2
A Bit of Sewing	10x12	Int	$99	3
A Bit of Sewing	11X14	Int	$121	5
A Bit of Sewing	11x14	Int	$50	3
A Bit of Sewing	11x14	Int	$132	4
A Bit of Sewing	11x14	Int	$61	3
A Bit of Sewing	13x16	Int	$99	4
A Brown Study	11x17	Int	$72	4
A Call at the Manor	12x16	Int	$275	5
A Chair for John	10x12	Int	$77	4
A Chair for John	10x16	Int	$110	3
A Chair for John	10x16	Int	$225	5
A Chair for John	11x14	Int	$99	4
A Chair for John	11X17	Int	$88	5
A Chair for John	12x16	Int	$143	3
A Chair for John	13X15	Int	$132	5
A Chair for John	13x16	Int	$231	5
A Chair for John	16X20	Int	$319	5
A Chair for John	18x22	Int	$77	2
A Classical Maid	12x16	Int	$143	3
A Cold Day	10x13	Int	$72	4
A Cold Day	14x17	Int	$132	3
A Cold Day	11X14	Int	$198	4
A Colonial Corner	10X13	Int	$72	2
A Colonial Corner	11x20	Int	$176	4
A Colonial Corner	13x16	Int	$176	5
A Colonial Corner	14x17	Int	$187	5
A Colonial Corner	16x20	Int	$44	2
A Colonial Dame	13x16	Int	$143	4
A Colonial Stair	9X15	Int	$83	3
A Comfortable Hour	14x17	Int	$72	3
A Comforting Cup	13x16	Int	$350	5
A Corner in China	11x13	Int	$176	4
A Corner in China	11x14	Int	$165	4
A Corner in China	14x17	Int	$231	3
A Corner in China	14x17	Int	$94	3
A Cozy Corner	11x14	Int	$132	4
A Cranford Tea	14x17	Int	$325	5
A Cranford Tea Pouring	13x15	Int	$330	3
A Daughter of the Revolution	12x16	Int	$83	3

A Daughter of the Revolution	12x16	Int	$83	3
A Daughter of the Revolution	14x17	Int	$176	4
A Deliberate Stitch	10x12	Int	$83	3
A Delicate Stitch	8x10	Int	$77	3
A Delicate Stitch	11x14	Int	$88	3
A Delicate Stitch	14x17	Int	$94	3
A Delicate Stitch	16x20	Int	$165	4
A Delicate Stitch	16x20	Int	$176	5
A Designing Maid	13x16	Int	$83	3
A Discovery	11x14	Int	$110	4
A Discovery	13X16	Int	$110	4
A Discovery	11x14	Int	$94	4
A Discovery	11x14	Int	$154	4
A Divining Cup	14x17	Int	$165	3
A Divining Cup	10x12	Int	$143	4
A Divining Cup	14X17	Int	$209	5
A Double Drawing Room	11x17	Int	$209	5
A Double Drawing Room	13x17	Int	$264	5
A Double Drawing Room	10x16	Int	$225	5
A Double Drawing Room	13x17	Int	$187	5
A Faerie Tale	16x20	Int	$319	5
A Family Heirloom	14x17	Int	$275	3
A Fine Effect	10x12	Int	$165	5
A Fleck of Sunshine	11x14	Int	$185	4
A Fleck of Sunshine	14x17	Int	$198	5
A Fleck of Sunshine	11x14	Int	$99	4
A Fruit Luncheon	11x14	Int	$187	4
A Fruit Luncheon	11x14	Int	$176	4
A Fruit Luncheon	11x14	Int	$231	5
A Fruit Luncheon	14X17	Int	$165	4
A Fruit Luncheon	14X17	Int	$231	5
A Gardner Parlor	10X12	Int	$110	4
A Gardner Parlor	11x14	Int	$83	4
A Goose Chase Pattern	11x14	Int	$297	4
A Grand'pa and Grand'ma Bed	10x16	Int	$187	5
A Grand'pa and Grand'ma Bed	12x16	Int	$209	4
A Gran'pa and Gran'ma Bed	14X17	Int	$165	4
A Hallway Glimpse	7X12	Int	$88	4
A Maid and a Mirror	11x17	Int	$220	4
A Mother of the Revolution	8x10	Int	$66	2
A Mother of the Revolution	13x16	Int	$99	3
A Musical Reverie	14x17	Int	$385	5
A New Market Belle	11x17	Int	$176	5
A Nutting Nook	10x16	Int	$88	3

A Nuttinghame Nook	11x17	Int	$132	3
A Nuttinghame Nook	10x16	Int	$99	5
A Nuttinghame Nook	12X18	Int	$154	4
A Nuttinghame Nook	8x14	Int	$143	4
A Pilgrim Daughter	13X16	Int	$253	5
A Present of Jewels	11x14	Int	$187	4
A Present of Jewels	14x17	Int	$83	3
A Romance of the Revolution	11x17	Int	$154	5
A Satisfied Customer	14x17	Int	$468	5
A Sip of Tea	9X11	Int	$116	3
A Sip of Tea	10x12	Int	$105	3
A Sip of Tea	11x14	Int	$99	4
A Sip of Tea	11x14	Int	$94	3
A Sip of Tea	12x15	Int	$94	2
A Sip of Tea	13x15	Int	$132	3
A Sip of Tea	13x15	Int	$110	3
A Sip of Tea	13X16	Int	$143	3
A Sip of Tea	14x17	Int	$154	5
A Sip of Tea	14x17	Int	$132	4
A Stately Tea Pouring	10x12	Int	$198	5
A Stately Tea Pouring	10x12	Int	$209	4
A Stitch in Time	9x11	Int	$83	3
A Stitch in Time	10X12	Int	$88	4
A Stitch in Time	10X12	Int	$110	4
A Stitch in Time	10x16	Int	$220	5
A Stitch in Time	11x14	Int	$83	3
A Stitch in Time	11x14	Int	$88	4
A Stitch in Time	11x14	Int	$154	4
A Stitch in Time	18x22	Int	$253	4
A Thrilling Romance	18x22	Int	$220	4
A True D.A.R.	14X17	Int	$149	3
A True D.A.R.	12x16	Int	$330	5
A Virginia Reel	14x17	Int	$286	5
A Virginia Reel	14X17	Int	$198	5
A Virginia Reel	14x17	Int	$363	5
A Virginia Reel	14x17	Int	$209	5
A Virginia Reel	16x20	Int	$425	5
A Virginia Reel	16x20	Int	$253	5
A Watched Pot	13x16	Int	$88	3
A Watched Pot	14x17	Int	$187	3
A Welcome Task	12x16	Int	$66	3
A Windsor Maid	14x17	Int	$165	3
Affectionately Yours	10x12	Int	$185	4
Affectionately Yours	10X12	Int	$105	4

Affectionately Yours	12x14	Int	$154	4
Affectionately Yours	13x16	Int	$121	4
Affectionately Yours	13x16	Int	$187	5
Afternoon Recreation	13x16	Int	$231	4
Afternoon Tea	14x17	Int	$121	3
Afternoon Tea	18x22	Int	$143	5
Afternoon Tea	14x17	Int	$116	3
Afternoon Tea	10x12	Int	$94	3
All Smiles	12X16	Int	$154	4
All Smiles	13x16	Int	$176	5
Almost Ready	11x14	Int	$99	3
Almost Ready	11X14	Int	$105	2
Almost Ready	13x17	Int	$265	4
Almost Ready	14x17	Int	$132	5
Almost Ready	14x17	Int	$121	4
An Absorbing Tale	13X17	Int	$209	5
An Afternoon Tea	11x14	Int	$176	4
An Afternoon Tea	12x16	Int	$132	3
An Afternoon Tea	12x18	Int	$39	2
An Afternoon Tea	13x16	Int	$121	3
An Afternoon Tea	13X16	Int	$99	2
An Afternoon Tea	13x18	Int	$116	3
An Afternoon Tea	13X22	Int	$143	5
An Afternoon Tea	14X17	Int	$132	4
An Afternoon Tea	16x20	Int	$143	4
An Afternoon Tea	18x22	Int	$154	4
An Afternoon Tea	20x28	Int	$231	4
An Afternoon Tea	26x30	Int	$374	5
An Elaborate Dinner	10x16	Int	$132	4
An Elaborate Dinner	11X14	Int	$121	4
An Elaborate Dinner	12x16	Int	$77	3
An Elaborate Dinner	13X16	Int	$99	3
An Elaborate Dinner	13X17	Int	$132	2
An Elaborate Dinner	14x17	Int	$61	2
An Elaborate Dinner	14x17	Int	$105	4
An Elaborate Dinner	18X22	Int	$132	5
An Elaborate Dinner	9x11	Int	$121	4
An Informal Call	13x16	Int	$105	3
An Informal Call	18x22	Int	$425	5
An Inspiration	13x16	Int	$330	5
An Interrupted Letter	14x17	Int	$165	4
An Interrupted Letter	18X22	Int	$198	3
An Interrupted Letter	14x17	Int	$220	5
An Interrupted Letter	11x14	Int	$77	3

An Old Chamber	12X15	Int	$198	4
An Old Colony Parlor	11x14	Int	$143	5
An Old Colony Parlor	11x14	Int	$185	4
An Old Drawing Room	11x14	Int	$308	5
An Old Drawing Room	11x14	Int	$88	4
An Old Drawing Room	10x12	Int	$110	3
An Old Drawing Room	10x12	Int	$143	5
An Old Newbury Corner	14x17	Int	$176	4
An Old Newbury Cupboard	14x17	Int	$154	5
An Old Parlor Corner (Walpole)	14x17	Int	$297	5
An Old Parlor Corner (Walpole)	14X17	Int	$506	5
An Old Time Romance	11x14	Int	$138	4
An Old Time Romance	16x20	Int	$425	5
An Old Time Romance	13x16	Int	$77	3
Ancient Treasures	14X17	Int	$121	3
Announcing the Engagement	11x14	Int	$176	5
Announcing the Engagement	11x14	Int	$165	5
Announcing the Engagement	11x14	Int	$220	4
Announcing the Engagement	13x16	Int	$413	5
Anxious to Please	12x14	Int	$550	5
At Paul Revere's	12x14	Int	$77	3
At the Fender	12x16	Int	$165	2
At the Fender	13x16	Int	$160	4
At the Fender	14x17	Int	$198	4
At the Spinnet	13x16	Int	$625	5
At the Spinnet	13x16	Int	$407	4
Awaiting Criticism	12X15	Int	$231	4
Birthday Flowers	12X16	Int	$209	4
Birthday Flowers	11x17	Int	$176	5
Birthday Flowers	11x17	Int	$121	5
Birthday Flowers	11x17	Int	$121	4
Braiding a Straw Hat	12x15	Int	$105	4
By the Grained Arch Bed	14x17	Int	$187	3
Calling on Priscilla	10x16	Int	$165	4
Caught Unaware	11x17	Int	$319	4
Christmas Jelly	10x14	Int	$99	4
Christmas Jelly	10x16	Int	$94	5
Christmas Jelly	11x14	Int	$61	1
Christmas Jelly	12X16	Int	$121	5
Christmas Jelly	12x16	Int	$275	3
City of Paris Papar	13x16	Int	$132	4
City of Paris Paper	10X16	Int	$121	4
Clarinda at Home	12x15	Int	$121	3
Close-Framed Interior	13x15	Int	$50	3

Colonial China	10x13	Int	$195	4
Colonial Dames at Tea	13x16	Int	$176	3
Colonial Dames at Tea	13x15	Int	$209	4
Colonial Dames at Tea	7x9	Int	$99	3
Confidences	12x15	Int	$176	3
Confidences	10X16	Int	$110	3
Cupboard Attractions	14X17	Int	$176	5
Cutting a Silhouette	12x16	Int	$187	4
Dainty China	10x12	Int	$88	3
Dainty China	12x20	Int	$94	3
Dainty China	15x18	Int	$132	4
Deliberation	14x17	Int	$132	4
Delightful	12X16	Int	$198	5
Delightful	13x17	Int	$187	5
Embroidering	10x12	Int	$154	4
Embroidering	10X12	Int	$110	5
Embroidering	11x14	Int	$94	4
Embroidering	12x16	Int	$143	4
Embroidering	15x19	Int	$88	4
Embroidering	18x22	Int	$99	3
Embroidering	18X22	Int	$154	4
Feminine Finery	12x16	Int	$231	4
Filling the Oven	8x10	Int	$143	4
Fireside Contentment	14x17	Int	$385	3
For A Little Guest	14x17	Int	$176	3
Good Night!	13x16	Int	$264	5
Good Night	13x16	Int	$50	2
Good Night	14x17	Int	$250	4
Good Night	14x17	Int	$99	3
Good Night!	15x22	Int	$253	5
Good Night	16x20	Int	$308	5
Good Night	16x20	Int	$242	5
Good Night	16x20	Int	$425	5
Good Night	18X22	Int	$264	4
Good Night	8x10	Int	$77	3
Grandfather's Clock	14x17	Int	$176	5
Grandfather's Clock	14x17	Int	$83	3
Grandmother's China	11x17	Int	$99	3
Grandmother's China	12x16	Int	$231	5
Grandmother's China	11X17	Int	$110	3
Grandmother's Sheffield	14x17	Int	$242	4
Grandmother's Sheffield	11x14	Int	$83	3
Great Grandma's Sewing	11x14	Int	$66	3
Great Grandma's Sewing	11x14	Int	$52	2

124

Harmony	13x16	Int	$143	4
Harmony	18X22	Int	$132	3
Harmony	18x22	Int	$143	3
Hospitable Preparations	10x12	Int	$121	3
In 1790	12x15	Int	$143	5
In the Brave Days of Old	11X14	Int	$94	4
In the Brave Days of Old	14X17	Int	$176	5
In the Brave Days of Old	11x13	Int	$175	4
In the Midst of her China	14x17	Int	$176	3
In the Midst of Her China	14x17	Int	$330	5
Is the Fire Ready?	14x17	Int	$176	5
Is the Fire Ready?	14x17	Int	$375	5
Is the Fire Ready?	14x17	Int	$220	5
Maidenly Reveries	14x17	Int	$143	4
Making A Rug	14x17	Int	$154	5
Making a Summer Hat	14x17	Int	$286	5
Mending	10x12	Int	$61	3
Mending	12x14	Int	$77	4
Mending	12X16	Int	$149	5
Mending	13x16	Int	$176	4
Mending	18x22	Int	$363	4
Mending Day	12x16	Int	$77	3
Mending Day	11x17	Int	$39	2
Mending the Quilt	10x12	Int	$99	3
Mirrored	11x14	Int	$121	4
Morning Duties	10x12	Int	$61	3
Morning Duties	10x12	Int	$105	4
Morning Duties	11x14	Int	$105	5
Morning Duties	11x14	Int	$132	4
Morning Duties	11x14	Int	$88	4
Morning Duties	11x14	Int	$175	4
Neighbors	14X17	Int	$198	5
Old Wentworth Days	10x12	Int	$185	5
Old Wentworth Days	18X22	Int	$220	5
Over the Teacups	14x17	Int	$121	5
Over the Teacups	14X17	Int	$132	4
Patchwork	12x14	Int	$198	4
Pinning the Lace	11x17	Int	$105	4
Pinning the Lace	11x17	Int	$143	4
Polishing the Pewter	10X13	Int	$143	3
Polishing the Sheffield	10x12	Int	$121	5
Preparing an °At Home'	10X16	Int	$132	3
Preparing an °At Home'	8x14	Int	$105	4
Preparing an °At Home'	13X22	Int	$176	5

Preparing an °At Home'	11X17	Int	$143	4
Pride	11x15	Int	$132	4
Private and Confidential	13x16	Int	$121	4
Private and Confidential	14x17	Int	$275	5
Proposing an Amendment	15x18	Int	$275	5
Proud as Peacocks	11x14	Int	$110	3
Proud as Peacocks	10x12	Int	$88	3
Prous as Peacocks	17X21	Int	$209	5
Prudence Drawing Tea	10x13	Int	$72	3
Prudence Drawing Tea	13x16	Int	$121	4
Prudence Drawing Tea	13X16	Int	$110	3
Prudence Drawing Tea	13x16	Int	$94	4
Prudence Drawing Tea	14x17	Int	$160	5
Prudence Drawing Tea	14x17	Int	$61	3
Prudence Drawing Tea	16x20	Int	$105	3
Prudence Drawing Tea	16X22	Int	$143	4
Ready for Callers	11x14	Int	$154	4
Ready for Callers	14X17	Int	$209	4
Rest After Sewing	11x17	Int	$105	3
Rest After Sewing	12x16	Int	$198	3
Rest After Sewing	12x18	Int	$127	3
Returning From a Walk	13x16	Int	$99	4
Returning From a Walk	13x16	Int	$187	4
Returning From a Walk	14x17	Int	$374	5
Returning From a Walk	14X17	Int	$242	5
Revealing A State Secret	13x16	Int	$209	5
Sewing by the Fire	11x14	Int	$165	4
Sewing by the Fire	11x14	Int	$154	4
Sewing by the Fire	11x14	Int	$99	4
Sewing by the Fire	11x14	Int	$132	4
Sewing by the Fire	12X15	Int	$110	5
Sheltered	12x15	Int	$94	5
Sunshine and Music	10x16	Int	$187	4
Sunshine and Music	11x17	Int	$209	5
Sunshine and Music	11x17	Int	$143	4
Sunshine and Music	12x15	Int	$195	4
Sunshine and Music	12x16	Int	$132	4
Sunshine and Music	13x16	Int	$121	4
Tabitha	18X22	Int	$176	5
Tea for Two	10X12	Int	$187	5
Tea for Two	11x14	Int	$66	3
Tea for Two	13X16	Int	$121	4
Tea for Two	14x17	Int	$55	3
Tea for Two	14x17	Int	$132	4

Tea in Yorktown Parlor	12x16	Int	$352	5
Tea in Yorktown Parlor	11x17	Int	$99	5
Tea in Yorktown Parlor	11x17	Int	$94	5
Thanksgiving Goodies	13X16	Int	$110	3
The 17th Century	11X14	Int	$88	3
The 17th Century	10x12	Int	$143	5
The Book Settle	10x16	Int	$165	5
The Book Settle	11x17	Int	$99	4
The Book Settle	11x17	Int	$55	3
The Book Settle	11x17	Int	$176	4
The Book Settle	12x20	Int	$187	4
The Book Settle	15x22	Int	$242	4
The Corner Cupboard	13x22	Int	$94	3
The Cup that Cheers	10x12	Int	$150	4
The Cup That Cheers	10x12	Int	$110	4
The Cup That Cheers	10x12	Int	$94	3
The Cup That Cheers	11x14	Int	$143	4
The Cup That Cheers	11x14	Int	$94	4
The Cup That Cheers	11X14	Int	$143	5
The Cup That Cheers	11X14	Int	$121	4
The Cup That Cheers	12x16	Int	$154	5
The Cup That Cheers	14x17	Int	$198	5
The Cup That Cheers	14x17	Int	$105	3
The Cup That Cheers	14x17	Int	$88	3
The Daguerreotype	14x17	Int	$253	4
The Days of Old	14x17	Int	$325	5
The Goose Chase Quilt	13x22	Int	$242	5
The Goose Chase Quilt	12x16	Int	$138	5
The Goose Chase Quilt	11x17	Int	$187	4
The Goose Chase Quilt	11x17	Int	$132	4
The Harpsicord	11x17	Int	$143	4
The Hepplewhite Tea	8x10	Int	$121	4
The Home Hearth	8x12	Int	$72	3
The Home Room	13x16	Int	$110	4
The Home Room	13x16	Int	$209	5
The Home Room	14x17	Int	$105	2
The Home Room	18x22	Int	$176	5
The Home Room	18x22	Int	$253	5
The Interrupted Letter	18X22	Int	$330	5
The Joy of Their Hearts	16X20	Int	$187	4
The Last Touches	12x16	Int	$325	5
The Last Word in Bonnets	14X17	Int	$297	5
The Maple Sugar Closet	14x17	Int	$143	5
The Maple Sugar Cupboard	11x17	Int	$110	4

The Maple Sugar Cupboard	12x15	Int	$94	4
The Maple Sugar Cupboard	12x16	Int	$105	3
The Maple Sugar Cupboard	12x20	Int	$61	3
The Maple Sugar Cupboard	13x17	Int	$55	2
The Maple Sugar Cupboard	14x17	Int	$116	4
The Maple Sugar Cupboard	14x17	Int	$187	5
The Maple Sugar Cupboard	14x17	Int	$83	3
The Maple Sugar Cupboard	14x17	Int	$253	5
The Maple Sugar Cupboard	14x17	Int	$143	4
The Maple Sugar Cupboard	15X22	Int	$198	5
The Maple Sugar Cupboard	18X22	Int	$176	4
The Maple Sugar Cupboard	22x30	Int	$143	3
The Maple Sugar Cupboard	30x38	Int	$165	4
The Morning Mail	14x17	Int	$28	1
The Morning Mail	13x16	Int	$231	3
The News in Brief	10X12	Int	$121	4
The Old Story	13X16	Int	$253	5
The Quilting Party	13x16	Int	$242	5
The Quilting Party	14x17	Int	$275	5
The Quilting Party	14x17	Int	$154	5
The Quilting Party	14x17	Int	$325	5
The Quilting Party	16X20	Int	$253	5
The Quilting Party	18x22	Int	$154	4
The Quilting Party	18X22	Int	$165	4
The Reception	13x17	Int	$110	4
The Rug Maker	11X14	Int	$187	4
The Rug Maker	11x14	Int	$138	3
The Rug Maker	11x14	Int	$175	4
The Rug Maker	14x17	Int	$94	3
The Rug Maker	14x17	Int	$308	5
The Rug Maker	14X17	Int	$165	3
The Saucy Bonnet	9X15	Int	$198	5
The Settle Nook	11x13	Int	$66	3
The Songs of Long Ago	13x16	Int	$198	4
The Sparkling Blaze	11X14	Int	$176	5
The Spinnet Corner	11X14	Int	$121	5
The Spinnet Corner	14x17	Int	$187	4
The Spinnet Corner	9x12	Int	$231	4
The Spinnet Corner	16x20	Int	$275	4
The Tangled Skein	11X14	Int	$66	3
The Tea Hour	13X16	Int	$132	4
The Tea Maid	13x16	Int	$11	1
The Tea Maid	12x14	Int	$209	4
The Treasure Bag	25X29	Int	$286	4

The Treasure Bag	10X12	Int	$94	4
The Window Garden	13x16	Int	$325	5
The Work Basket	9x11	Int	$44	3
Tres Agreable	12X16	Int	$176	5
Trimming the Pie	14x17	Int	$110	3
Turning the Flapjack	14x17	Int	$295	5
Turning the Flapjack	13x16	Int	$242	5
Twin Miniatures	11X14	Int	$231	5
Uncle Sam	13x16	Int	$121	4
Very Satisfactory	16x20	Int	$375	4
Very Satisfactory	13x16	Int	$143	4
Very Satisfactory	13x15	Int	$110	4
Very Satisfactory	8x10	Int	$50	3
Watchful Waiting	14X17	Int	$121	3
Watchful Waiting	12x16	Int	$176	5
What A Beauty!	14x17	Int	$286	5
What Shall I Answer?	11x15	Int	$132	4
Wig Wag Churning	14x17	Int	$295	5
Winding the Tall Clock	14x17	Int	$165	4

Untitled Interior Pictures

Wallace Nutting Untitled Interior scenes generally consisted of smaller Indoor views with mat sizes ranging from 5"x7" - 10"x12". In most instances, Untitled Interiors were smaller versions of Nutting's more popular and best-selling Colonial Indoor pictures. Typical scenes included women, usually near a large fireplace, performing some common household chore...sewing, cooking, polishing silver, reading, braiding a rug, etc. Of the Untitled Interior pictures we reviewed, most followed these pricing patterns:

Mat Size	Price Range	Average Price
5"x7"	$35 - $125	$75
7"x9"	$35 - $150	$90
7"x11"	$40 - $165	$110
8"x10"	$40 - $150	$110
8"x12"	$40 - $200	$115
10"x12"	$60 - $200	$135

Foreign Scenes

A Canterbury Gate	14x17	For	$121	3
A Cape Mill	11x14	For	$325	5
A Derby Village	12x16	For	$83	3
A Dutch Bridge	11x14	For	$413	4
A Familiar Path	13x16	For	$121	5
A Garden of Dreams	13x16	For	$176	5
A Garden of Larkspur	8X11	For	$72	3
A Garden of Larkspur	9x11	For	$88	5
A Garden of Larkspur	10X12	For	$61	4
A Garden of Larkspur	11X13	For	$55	3
A Garden of Larkspur	11x14	For	$41	4
A Garden of Larkspur	11x14	For	$220	5
A Garden of Larkspur	12x16	For	$88	5
A Garden of Larkspur	13x15	For	$61	4
A Garden of Larkspur	13x16	For	$77	5
A Garden of Larkspur	14X16	For	$132	4
A Garden of Larkspur	14X17	For	$50	4
A Garden of Larkspur	14X17	For	$88	4
A Garden of Larkspur	14x17	For	$143	4
A Garden of Larkspur	14x17	For	$94	3
A Garden of Larkspur	14x17	For	$61	3
A Garden of Larkspur	16x20	For	$176	4
A Garden of Larkspur	16x20	For	$33	2
A Garden of Larkspur	16X20	For	$99	4
A Garden of Larkspur	16x20	For	$297	5
A Garden of Larkspur	22x30	For	$88	4
A Golden River	10x12	For	$55	5
A Greeting	10X12	For	$77	4
A Greeting	8x10	For	$132	3
A Greeting	9X12	For	$55	3
A Hawthorn Bridge	13X16	For	$88	2
A Joyous Anniversary	13x16	For	$150	4
A Killarney Castle and Cove	11x17	For	$154	4
A Killarney Castle and Cove	12x16	For	$286	5
A Lane in Sorrento	11X17	For	$330	4
A Lane in Sorrento	10x16	For	$66	3
A Listless Day	12x16	For	$143	3
A Listless Day	11x14	For	$231	5
A Listless Day	13x16	For	$105	3
A Little Dutch Cove	11x14	For	$143	4

A Little Killarney Lake	13x16	For	$88	5
A Little Killarney Lake	20x24	For	$198	5
A Little Killarney Lake	16X20	For	$121	4
A Lough Gill Cottage	10X12	For	$132	5
A Nova Scotia Idyl	10x12	For	$99	5
A Nova Scotia Idyl	10X12	For	$143	5
A Nova Scotia Idyl	10x12	For	$99	5
A Path of Roses	13x17	For	$77	3
A Path of Sweetness	13x17	For	$83	5
A Peaceful Stretch	11x17	For	$132	4
A Peaceful Stretch	12x18	For	$187	4
A Peaceful Stretch	10x16	For	$143	4
A Peak in Donegal	13x16	For	$220	5
A River Arch	13x16	For	$154	4
A Rug Pattern	11x14	For	ERR	3
A Rug Pattern	12X16	For	$396	4
A Rug Pattern	13x16	For	$121	5
A Sheltered Brook	16x20	For	$94	5
A Somerton Entrance	13x16	For	$231	4
A Valley in the Pyrenees	14x17	For	$61	3
A Valley in the Pyrenees	10X12	For	$44	3
A Valley in the Pyrenees	13x16	For	$286	5
A Vista of Amalfi	10x12	For	$209	5
A Water Garden in Venice	10x12	For	$176	5
A Westport Garden	13x16	For	$116	4
A Wyeside Valley	13x16	For	$187	5
An English Door	10x13	For	$39	3
An English Door	10X12	For	$138	4
An English Door	10x12	For	$55	3
An Irish Brook	13x16	For	$83	4
An Italian Spring	11x14	For	$33	2
An Old Castle Stair	11x17	For	$264	4
Arches, County Kerry	13x16	For	$72	4
Around the Cottage End	13x16	For	$66	3
Around the Cottage End	13x16	For	$110	5
Below the Arches	18x22	For	$132	3
Below the Arches	10X14	For	$66	4
Below the Arches	18x22	For	$176	5
Bonny Dale	10x12	For	$77	4
Bonny Dale	10x12	For	$187	4
Bossington Street	12x16	For	$110	5
Bridge of Three Arches	11X14	For	$143	3
Brook Paths	13x16	For	$375	5
By Cottage Walls	11x14	For	$132	3

131

By the Old Arch	9x12	For	$44	4
By the Old Arch	13x16	For	$132	5
By the Old Arch	13x16	For	$121	4
Caherlough	15x22	For	$154	3
Cappuchini Pergola	8x10	For	$176	5
Capri Bay	13x15	For	$358	5
Cetera	14x17	For	$880	5
Chambord from the Casson	13x15	For	$220	4
Chambord From the Casson	12x15	For	$325	4
Cottage in the Lane	11x17	For	$66	4
Coves of Killarney	13x16	For	$187	4
Doune Banks	10X12	For	$50	5
Doune Banks	14x17	For	$55	5
Durham	13x16	For	$132	3
Durham	14x17	For	$110	3
Durham	14x17	For	$209	5
Durham	14x17	For	$198	4
Durham	14x17	For	$154	4
Durham	14x17	For	$253	5
Dutch Sails	10X16	For	$473	5
Dutch Sails	11x17	For	$187	4
Dutch Sails	10x16	For	$220	4
Dykeside Blossoms	10x16	For	$50	3
D'Este Garden Tivoli	10x12	For	$105	2
Evangeline Lane	16X20	For	$341	5
Evangeline Lane, Nova Scotia	14X18	For	$143	4
Evening at Killarney	12x16	For	$176	4
Fair Italy	14x17	For	$187	4
Five O'Clock	12x20	For	$154	4
Five O'Clock	15x22	For	$72	2
Five O'Clock	11x19	For	$116	3
Five o'Clock	15x22	For	$341	5
Foot Bridge and Ford	13x16	For	$176	5
Gloucester Cloister	16x20	For	$550	5
Grandmother's Garden	10X12	For	$110	5
Grandmother's Garden	11x13	For	$165	5
Grandmother's Garden	13x16	For	$116	4
Grandmother's Garden	14x17	For	$99	3
Hawthorn Bridge	9x12	For	$61	3
Hawthorn Bridge	14X17	For	$110	3
Hawthornden	13x16	For	$110	4
Hawthornden	10x12	For	$165	4
Hawthornden	14x17	For	$154	4
Holland Express	11x17	For	$231	4

Hollyhock Cottage	10x12	For	$88	4
Hollyhock Cottage	10x12	For	$77	3
Hollyhock Cottage	11x13	For	$99	3
Hollyhock Cottage	11x14	For	$99	3
Hollyhock Cottage	11X14	For	$61	4
Hollyhock Cottage	12x16	For	$121	3
Hollyhock Cottage	13x15	For	$55	4
Hollyhock Cottage	13x16	For	$61	4
Hollyhock Cottage	13x16	For	$209	5
Hollyhock Cottage	13x16	For	$132	4
Hollyhock Cottage	14x17	For	$66	3
Hollyhock Cottage	14X17	For	$99	4
Hollyhock Cottage	16x20	For	$105	4
Hollyhock Cottage	16x20	For	$72	3
Hollyhock Cottage	18x22	For	$99	5
In the Peak Country	13x16	For	$83	4
In Worden	10x16	For	$633	5
Joy Path	9x11	For	$77	4
Joy Path	9x11	For	$55	4
Joy Path	11x14	For	$88	3
Joy Path	13x16	For	$55	2
Joy Path	16x20	For	$308	5
Joy Path	16x20	For	$143	5
Kent Curves	11X14	For	$132	4
Larkspur	10x12	For	$88	5
Larkspur	10X12	For	$50	4
Larkspur	11x14	For	$72	4
Larkspur	11x14	For	$83	5
Larkspur	11x14	For	$39	3
Larkspur	11x14	For	$83	3
Larkspur	11x14	For	$66	3
Larkspur	11x14	For	$99	4
Larkspur	13x16	For	$121	4
Larkspur	13X17	For	$22	3
Larkspur	14x17	For	$28	2
Larkspur	14x17	For	$55	3
Larkspur	14x17	For	$36	3
Larkspur	16x20	For	$88	3
Larkspur	16x20	For	$121	5
Larkspur	16x20	For	$83	5
Larkspur	16X20	For	$88	3
Larkspur	22x28	For	$275	5
Larkspur	22x28	For	$116	4
Lincoln Gate	16x20	For	$462	5

Litchfield Minster	14x17	For	$154	5
Litchfield Minster	14x17	For	$143	5
Litchfield Minster	14x17	For	$396	5
Litchfield Minster	16x20	For	$165	3
Litchfield Minster	16X20	For	$462	5
Living Pillars	12x16	For	$143	5
Lorna Doone	10x12	For	$165	4
Lorna Doone	9x11	For	$110	4
Lorna Doone	14X17	For	$880	4
Lorna Doone Brook	11x14	For	$61	5
Lorna Doone Brook	12X15	For	$55	2
Lugano's Heights	11x14	For	$154	4
Lugano's Heights	11x14	For	$72	4
Meadow Beauty	14x17	For	$61	3
Meadow Beauty	10X12	For	$55	4
Midsummer Vale	13x16	For	$143	4
Midsummer Vale	16x20	For	$77	3
Nethercote	10x12	For	$99	5
Nethercote	13X16	For	$132	4
Nethercote	13x16	For	$88	5
Nethercote	13x16	For	$198	5
Nethercote	18x22	For	$154	3
Old Italy	16x20	For	$105	3
Old Venice	11x14	For	$297	3
On the Avon	14x17	For	$154	4
On the Avon	14x17	For	$220	5
On the Heights	9x15	For	$352	5
On the Heights	10x15	For	$154	3
Patti's Favorite Walk	14x17	For	$165	5
Patti's Favorite Walk	10x12	For	$154	4
Positano	15x18	For	$77	3
Positano at Night	16x20	For	$209	5
Rheinstein	12x15	For	$875	5
Ross-on Wye	12x16	For	$220	5
Ruins of Hadrian's Villa	11x14	For	$295	5
Sailing Among Windmills	11X17	For	$198	5
Sailing Among Windmills	13x16	For	$375	5
Sailing Among Windmills	14x17	For	$297	5
Salisbury	12x15	For	$143	4
Scotland Beautiful	13x16	For	$176	5
Scotland Forever	12x16	For	$77	4
Sleeping Canal	10x14	For	$187	3
Smoke of the Evening Fires	10x16	For	$99	3
Smoke of the Evening Fires	10x16	For	$99	3

Spanning the Glen	10x12	For	$83	3
Spanning the Glen	10x12	For	$145	4
Spring's First Green	11x14	For	$66	4
St Mary's in May	12X16	For	$143	5
St Mary's in May	14x17	For	$110	4
Stepping Stones at Bolten Abbey	18x22	For	$352	3
Stony Brook Blossoms	13x16	For	$231	5
Summer Decorations	10x13	For	$44	5
Swan Cove	20x28	For	$825	5
Thatched Dormers	13x16	For	$375	5
The Angel Garden	12x20	For	$297	5
The Arches of Rievault	10x12	For	$83	3
The Bay of Capri	14x17	For	$248	3
The Bridge Path	14x20	For	$176	4
The Brook's Mouth	12X22	For	$990	5
The Brook's Mouth	7x9	For	$99	3
The Canal Road	9x12	For	$72	3
The Chimes Tower	11X14	For	$220	5
The Church and the Bridge	11x14	For	$275	5
The Cottage Garden	10x16	For	$209	5
The Cottage Garden	10x14	For	$105	3
The Cottage Garden	10x13	For	$143	4
The Donjon	16x20	For	$385	4
The Expected Letter	11x14	For	$231	4
The Expected Letter	11x14	For	$523	5
The Foot of the Moorlands	11x14	For	$88	4
The Garden of Dreams	9x11	For	$105	4
The Gift of the Hills	12x16	For	$94	5
The Goodman is Coming	10X12	For	$33	2
The Goodman is Coming	10x12	For	$61	3
The Goodman is Coming	11x14	For	$132	3
The Highlands	12x16	For	$110	5
The Highlands	11x14	For	$99	5
The House Lane	13x17	For	$72	3
The Italian Spring	11x14	For	$176	5
The Italian Spring	10x12	For	$105	4
The Italian Spring	11x14	For	$66	3
The Laune at Dunloe	12x16	For	$121	5
The Mills at the Turn	10x12	For	$176	4
The Mills at the Turn	11x14	For	$220	4
The Mills at the Turn	11X14	For	$187	5
The Mills at the Turn	11x14	For	$121	4
The Mills at the Turn	13x15	For	$99	3
The Mills at the Turn	13X15	For	$165	3

The Mills at the Turn	18x22	For	$187	3
The Nest	10x12	For	$99	4
The Nest	11X14	For	$61	4
The Nest	11x14	For	$83	4
The Nest	11x14	For	$88	4
The Nest	12x16	For	$55	3
The Nest	13x15	For	$209	5
The Nest	13x16	For	$165	5
The Nest	13x16	For	$121	5
The Nest	26x30	For	$165	4
The Old Mill, Amalfi	12x16	For	$473	4
The Parthenon	13x16	For	$303	4
The Pasture at Muckross	14x17	For	$165	5
The Path Gate	10x13	For	$88	5
The Pergola, Amalfi	10x12	For	$143	5
The Pergola, Amalfi	11x14	For	$242	5
The Pergola, Amalfi	11X14	For	$121	5
The Pergola, Amalfi	12x14	For	$61	3
The Pergola, Amalfi	13x16	For	$39	2
The Pergola, Amalfi	14x17	For	$99	4
The Pergola, Amalfi	14X17	For	$105	5
The Pergola, Amalfi	14X17	For	$72	4
The Pergola, Amalfi	14x17	For	$66	5
The Pergola, Amalfi	14x17	For	$132	4
The Pergola, Amalfi	14x17	For	$127	4
The Pergola, Amalfi	14X17	For	$94	2
The Rug Pattern	13x16	For	$176	5
The Sorrento-Amalfi Road	14x18	For	$440	5
The Time of Roses	13X16	For	$66	2
The Time of Roses	10x13	For	$39	5
The Tranquil Vale	11x17	For	$88	4
The Vale of the Derwent	14x17	For	$253	5
The Valley of the Pyrennes	10x12	For	$171	4
The Vicarage	12x16	For	$66	3
Under Ivy Bridge	14X17	For	$99	4
Under Ivy Bridge	14x17	For	$165	5
Under the Sundial	10x16	For	$286	5
Vesuvius from Sorrento Road	10x16	For	$231	5
Vico Equesne	13x15	For	$264	4
Vico Esquene	12x15	For	$350	5
Village End	13X22	For	$99	4
Village End	12X15	For	$154	5
Warwick Castle	11x14	For	$94	3
Wells from the Palace Pool	14x17	For	$275	5

Windings in Holland	*10X12*	*For*	*$110*	*5*
Windings in Holland	*11x14*	*For*	*$50*	*2*
Windsor Roadside	*13x16*	*For*	*$176*	*5*

Untitled Foreign Pictures

Wallace Nutting Untitled Foreign pictures generally consisted of smaller Foreign views, with mat sizes ranging from 5"x7" - 10"x12". In most instances, Untitled Foreign scenes were smaller versions of Wallace Nutting's more popular and best-selling Foreign scenes. These pictures usually included cottages, windmills, gardens, castles, cathedrals, and other stately houses.

The Untitled Foreign pictures that we observed ranged in price from $35 - $265, with the actual subject being a more important determinant of price than size. The average price of Foreign pictures that we observed was **$95**. Untitled versions of Nutting's best-selling Foreign pictures... **Larkspur, A Garden of Larkspur, Hollyhock Cottage, Litchfield Minster,** etc..generally brought the lower prices. Rarer pictures in better condition brought proportionally higher prices.

Miscellaneous Unusual Scenes

A Bird in the Hand	14x17	Bird	$341	4
Comfort and a Cat	12x14	Cat	$116	2
Comfort and a Cat	13x15	Cat	$330	4
Comfort and a Cat	13x15	Cat	$176	3
Comfort and a Cat	13x15	Cat	$325	5
Comfort and a Cat	13x16	Cat	$550	5
Comfort and a Cat	14x15	Cat	$220	3
Comfort and the Cat	10x12	Cat	$187	3
Comfort and the Cat	13x15	Cat	$220	3
Comfort and the Cat	13x15	Cat	$413	3
Comfort and the Cat	14x17	Cat	$330	5
Comfort and the Cat	14x17	Cat	$385	4
Fireside Fancies	13x16	Cat	$209	5
The Ancestral Cradle	15x22	Cat	$165	3
The Ancestral Cradle	13x17	Cat	$525	5
The Old Home	11x17	Cat	$187	3
The Old Home	11x17	Cat	$187	4
The Old Home	13x22	Cat	$550	4
The Old Home	13x17	Cat	$176	4
Three Chums	10x12	Cat	$462	5
Three Chums	11x14	Cat	$375	5
Three Chums	14x17	Cat	$275	5
Three Chums	14X17	Cat	$220	4
Three Chums	8X10	Cat	$385	5
Three Chums	9x11	Cat	$468	4
Untitled Cat Scene	7x9	Cat	$248	5
A Look Ahead	8x10	Cow	$220	3
Arlington Hills	11x20	Cow	$1,018	5
Blossom Peak	12x20	Cow	$440	4
B&W Cow Scene	9x12	Cow	$99	3
Four O'Clock	14X17	Cow	$1,430	5
Four O'Clock	11X13	Cow	$660	3
Four O'Clock	14x17	Cow	$1,100	4
Heifers by the Stream	10x12	Cow	$330	5
Heifers by the Stream	8X12	Cow	$275	5
Large, Untitled Cow Picture	13x16	Cow	$743	4
Pasture Dell	13x16	Cow	$1,183	5
Priscilla Among the Heifers	12x16	Cow	$1,705	5
The Meadow Pasture	11x17	Cow	$286	4
Untitled Cows	7x10	Cow	$220	4

Untitled Cows	7x11	Cow	$352	4
Untitled Cows	7X11	Cow	$187	3
Untitled Cows	7x11	Cow	$253	5
Untitled Cows	8x12	Cow	$250	5
Untitled °Feminine Curiousity'	13X16	Cow	$220	3
Dog-On-It	7X11	Dog	$1,293	4
Dog-On-It	7x11	Dog	$1,100	4
Dog-On-It	7x11	Dog	$963	4
The Meeting Place	25x29	Horse	$1,045	5
The Meeting Place	18x22	Horse	$2,750	5
Off for the Legislature	13x16	Horse	$2,035	5
A Favorite Corner	10x12	Sheep	$165	3
A Favorite Corner	10x12	Sheep	$154	3
A Favorite Corner	11x14	Sheep	$143	3
A Favorite Corner	11X14	Sheep	$176	5
A July Pasture	10x16	Sheep	$451	5
A Warm Spring Day	11X14	Sheep	$143	4
A Warm Spring Day	11x17	Sheep	$374	5
A Warm Spring Day	11x17	Sheep	$143	4
A Warm Spring Day	12X16	Sheep	$187	4
A Warm Spring Day	12X18	Sheep	$187	4
A Warm Spring Day	12x20	Sheep	$198	4
A Warm Spring Day	12x20	Sheep	$165	3
A Warm Spring Day	13x16	Sheep	$264	5
A Warm Spring Day	14x17	Sheep	$231	4
A Warm Spring Day	14X17	Sheep	$209	4
A Warm Spring Day	14x20	Sheep	$165	3
A Warm Spring day	14x20	Sheep	$231	5
A Warm Spring Day	14x22	Sheep	$242	4
A Warm Spring Day	15x22	Sheep	$352	5
A Warm Spring Day	15x22	Sheep	$176	3
A Warm Spring Day	15x22	Sheep	$220	5
A Warm Spring Day	15x22	Sheep	$231	5
A Warm Spring Day	16x20	Sheep	$231	4
A Warm Spring Day	18x22	Sheep	$143	4
A Warm Spring Day	22x30	Sheep	$275	4
A Willow Pastoral	12X16	Sheep	$297	5
Lambs at Rest	11x14	Sheep	$330	5
Lambs at Rest	10x12	Sheep	$187	4
Mary's Little Lamb	6X8	Sheep	$66	4
Mary°s Little Lamb	10x12	Sheep	$264	5
Mary's Little Lamb	11x13	Sheep	$198	4
Mary's Little Lamb	13x16	Sheep	$220	5
Mary's Little Lamb	14x17	Sheep	$350	5

New Life	11x14	Sheep	$187	5
Not One of the 400	12x16	Sheep	$220	3
Not One of the 400	13x16	Sheep	$176	5
Not One of the Four Hundred	13x16	Sheep	$209	5
Not One of the Four Hundred	13x16	Sheep	$253	3
On the Slope	10x16	Sheep	$198	5
On the Slope	11X13	Sheep	$116	2
On the Slope	11X17	Sheep	$209	5
On the Slope	11x17	Sheep	$220	5
On the Slope	12x20	Sheep	$121	3
On the Slope	13X17	Sheep	$187	4
On the Slope	13x18	Sheep	$319	5
On the Slope	13x22	Sheep	$193	3
On the Slope	13x22	Sheep	$198	4
On the Teith	13x16	Sheep	$187	5
Seeking the Shade	11x14	Sheep	$308	5
Sheep Grazing	14x17	Sheep	$105	4
The Breakfast Hour	11x17	Sheep	$121	3
The Breakfast Hour	9x15	Sheep	$165	3
The Life of the Golden Age	8x16	Sheep	$143	2
The Life of the Golden Age	9x16	Sheep	$105	2
The Life of the Golden Age	9x17	Sheep	$121	3
The Life of the Golden Age	11x17	Sheep	$297	5
The Life of the Golden Age	11x17	Sheep	$264	4
The Life of the Golden Age	12x20	Sheep	$176	3
The Life of the Golden Age	12x20	Sheep	$165	3
The Life of the Golden Age	14x20	Sheep	$275	5
The Life of the Golden Age	15x22	Sheep	$176	4
The Narragansett Country	14X21	Sheep	$253	3
The Pasture at Muchross	6X14	Sheep	$110	4
Under the Blossoms	14x17	Sheep	$99	3
Under the Blossoms	14X17	Sheep	$264	5
Under the Blossoms	13x16	Sheep	$176	5
Under the Blossoms	13x15	Sheep	$286	5
Untitled Sheep	4x10	Sheep	$99	3
Untitled Sheep	7x9	Sheep	$154	5
Untitled Sheep	7X9	Sheep	$83	3
A Call for More	10x12	Child	$143	3
A Call for More	11x14	Child	$154	4
A Call for More	11x14	Child	$154	3
A Dutch Knitting Lesson	10x14	Child	$908	5
A Literary Damosel	11x14	Child	$633	4

A Little Helper	14x17	Child	$750	5
A Little Helper	14x17	Child	$550	5
A Patchwork Siesta	14x17	Child	$1,045	5
An Airing at the Haven	14x17	Child	$550	3
At the Well, Sorrento	12x16	Child	$495	5
At the Well, Sorrento	10x14	Child	$83	3
At the Well, Sorrento	10X16	Child	$231	4
At the Well, Sorrento	14X17	Child	$468	4
Blowing Bubbles	5x9	Child	$960	5
Boys at Positano	13x16	Child	$908	5
Cottages on the Old Sod	11x14	Child	$688	5
Helping Mother	14x17	Child	$352	5
The Ancestral Cradle	15X22	Child	$330	4
The Coming Out of Rosa	10x12	Child	$110	4
The Coming Out of Rosa	11x14	Child	$88	3
The Coming Out of Rosa	11x14	Child	$220	4
The Coming Out of Rosa	14x17	Child	$121	3
The Coming Out of Rosa	14X17	Child	$165	5
The Coming Out of Rosa	14x17	Child	$154	4
The Coming Out of Rosa	14x17	Child	$231	5
The Coming Out of Rosa	14x17	Child	$99	3
The Coming Out of Rosa	14x17	Child	$187	5
The Coming Out of Rosa	14x17	Child	$143	4
The Coming Out of Rosa	16x20	Child	$143	4
The Guardian Mother	12x16	Child	$4,950	5
The Guardian Mother	9x14	Child	$2,145	5
The Old Settee	11X17	Child	$523	4
The Whirling Candlestand	10x12	Child	$198	4
The Whirling Candlestand	11x14	Child	$308	5
The Whirling Candlestand	11x14	Child	$303	5
The Whirling Candlestand	11x14	Child	$418	5
The Whirling Candlestand	8X10	Child	$105	3
Toward Slumberland	14x17	Child	$1,430	5
Untitled Child	11x14	Child	$853	5
Untitled Child	10x12	Child	$715	5
Untitled Child	8x10	Child	$484	5
Untitled Children in Carriage	14x17	Child	$715	3
Untitled Interior with Child	7x9	Child	$121	4
Untitled Interior with Child	8x10	Child	$242	3
Untitled °Posing'	7x9	Child	$88	5
Untitled "Posing"	7X9	Child	$72	3
Untitled "Posing"	7X9	Child	$77	3
Untitled °Posing'	7x9	Child	$61	3
Untitled °Posing'	7x9	Child	$132	4

Untitled °Posing'	7x9	Child	$77	5
Wavering Footsteps	14x17	Child	$132	3
A Basket of Gourds	9x13	Floral	$517	5
A Basket Running Over	16x20	Floral	$1,100	5
A Blue Lustre Pitcher	6x8	Floral	$198	3
Above The Big Mahogany	13x16	Floral	$352	5
Above The Big Mahogany	8x10	Floral	$375	5
Cosmos and Larkspur	13x16	Floral	$963	5
Hollyhocks	13x16	Floral	$440	5
Large Floral	11x14	Floral	$341	5
Large Floral	13x17	Floral	$660	5
Large Floral	11x17	Floral	$737	5
Large Floral	16X20	Floral	$385	5
Large Floral	16X20	Floral	$374	4
Meadow Lilies	13x16	Floral	$688	5
Mexican Zinnias	13x16	Floral	$671	5
Mexican Zinnias	8x10	Floral	$275	4
The Dahlia Jar	8X10	Floral	$308	5
The Dahlia Jar	8X10	Floral	$330	5
Untitled Floral	6x8	Floral	$94	4
Untitled Floral	3x4	Floral	$220	5
Untitled Floral	7x9	Floral	$110	4
Untitled Floral	7x9	Floral	$143	5
Untitled Floral	6x8	Floral	$143	4
Untitled Floral	7x9	Floral	$83	4
Untitled Floral	6x8	Floral	$231	5
Untitled Floral	8x10	Floral	$385	5
Untitled Floral	6x8	Floral	$231	5
Untitled Floral	7x9	Floral	$105	3
Untitled Floral	3x4	Floral	$198	5
Untitled Floral	7x9	Floral	$220	5
Untitled Floral	6x8	Floral	$138	5
Untitled Floral	6x8	Floral	$187	4
Untitled Floral	6x8	Floral	$143	4
Untitled Floral	6X8	Floral	$121	4
Untitled Floral	7x9	Floral	$143	5
Untitled Floral	7x9	Floral	$110	4
Untitled Floral	8x10	Floral	$165	5
Untitled Floral	7x9	Floral	$143	5
Untitled Floral	7x11	Floral	$121	3
Untitled Floral	8x10	Floral	$220	5
Untitled Floral	6X8	Floral	$154	4

Untitled Floral	7x9	Floral	$66	4
Zinnias	11x14	Floral	$358	5
Indian Maidens	12X15	Indian	$825	4
The Sunrise Call	14x17	Indian	$1,595	5
A Heart Chord	14x17	Man	$990	5
A Token for Easter	13x16	Man	$363	3
An Old Parlor Idyl	14x17	Man	$473	5
An Old Time Gallant	13x16	Man	$462	5
An Old Time Idyl	13x16	Man	$1,045	5
An Old Tune Revived	13x16	Man	$990	5
Drying Apples	10x12	Man	$308	3
Drying Apples	12x14	Man	$605	5
Drying Apples	13x16	Man	$429	4
Drying Apples	13x16	Man	$578	4
Drying Apples	14x17	Man	$770	5
Drying Apples	14X17	Man	$798	5
Hesitancy	13x16	Man	$429	5
Looking and Longing	8x13	Man	$578	4
Miniature Interior	4X5	Man	$116	4
Preparing for Thanksgiving	14x17	Man	$94	3
The Ambush of a Redcoat	13X16	Man	$297	4
The Easy Mark At Home	6x8	Man	$605	4
The Redcoat	9x11	Man	$50	3
The Way It Begins	12X14	Man	$715	5
The Way It Begins	13x16	Man	$660	5
The Way It Begins	13x16	Man	$297	4
The Way It Begins	14x17	Man	$220	3
Untitled Man in Red Coat	8x10	Man	$176	3
Garden Miniature	4x5	Mina	$66	5
Garden Miniature	4x5	Mina	$77	4
Garden Miniature	4x5	Mina	$66	5
Garden Miniature	4x5	Mina	$66	5
Garden Miniature	4x5	Mina	$77	4
Garden Miniature	4x5	Mina	$72	5
Floral Miniature	4x5	Mina	$176	5
Floral Miniature	4x5	Mina	$132	5
Floral Miniature	4X5	Mina	$121	5
Floral Miniature	4x5	Mina	$198	5

Floral Miniature	4x5	Mina	$132	5
Floral Miniature	4X5	Mina	$132	5
Floral Miniature	4x5	Mina	$143	5
Floral Miniature	4x5	Mina	$231	5
Floral Miniature	4x5	Mina	$176	5
Floral Miniature	4x5	Mina	$110	4
Floral Miniature	4x5	Mina	$132	5
Floral Miniature	4x5	Mina	$187	5
Exterior Miniature	4x5	Mina	$50	5
Exterior Miniature	4x5	Mina	$72	5
Exterior Miniature	4x5	Mina	$66	4
Exterior Miniature	4x5	Mina	$55	5
Exterior Miniature	4x5	Mina	$50	4
Exterior Miniature	4x5	Mina	$33	5
Exterior Miniature	4x5	Mina	$72	4
Exterior Miniature	4x5	Mina	$72	4
Exterior Miniature	4x5	Mina	$72	4
Exterior Miniature	4x5	Mina	$66	4
Exterior Miniature	4x5	Mina	$44	5
Exterior Miniature	4x5	Mina	$55	4
Exterior Miniature	4x5	Mina	$61	4
Exterior Miniature	4x5	Mina	$22	2
Exterior Miniature	4x5	Mina	$55	4
Exterior Miniature	4x5	Mina	$61	5
Exterior Miniature	4x5	Mina	$44	4
Exterior Miniature	4x5	Mina	$83	5
Exterior Miniature	4x5	Mina	$61	4
Foreign Miniature	4x5	Mina	$77	4
Foreign Miniature	4x5	Mina	$176	4
Foreign Miniature	4x5	Mina	$231	4
Interior Miniature	4x5	Mina	$110	5
Interior Miniature	4x5	Mina	$55	4
Interior Miniature	4x5	Mina	$154	5
Interior Miniature	4x5	Mina	$110	5
Interior Miniature	4x5	Mina	$99	5
Interior Miniature	4x5	Mina	$99	5
Interior Miniature	4x5	Mina	$88	5
Interior Miniature	4x5	Mina	$88	5
Interior Miniature	4x5	Mina	$110	4
Miniature °All Sunshine'	4x5	Mina	$154	4
Miniature °Natural Bridge'	4x5	Mina	$61	4
The Harvest Field, Bucks Cty	13x16	Pumpki	$1,320	5

An Atlantic Barrier	13x16	Sea	$374	4
Cypress Heights	18x22	Sea	$715	5
La Jolla	20x28	Sea	$688	4
La Jolla	14x17	Sea	$231	3
La Jolla	13x16	Sea	$231	5
La Jolla	14x17	Sea	$963	5
Large Seascape	20X40	Sea	$264	3
Large °Swirling Seas'	20x30	Sea	$578	5
Maine Coast Sky	10x12	Sea	$209	5
Maine Coast Sky	11x13	Sea	$198	4
Maine Coast Sky	11X14	Sea	$352	5
Maine Coast Sky	11x14	Sea	$242	5
Maine Coast Sky	11x14	Sea	$231	3
Maine Coast Sky	14x17	Sea	$440	5
Ocean Eddies	11x17	Sea	$495	5
Rhode Island Coast	15x22	Sea	$231	4
Sea Ledges	11x14	Sea	$209	5
Sea Ledges	11X14	Sea	$110	3
Sea Ledges	11x17	Sea	$143	4
Sea Ledges	12x20	Sea	$110	3
Sea Ledges	13x15	Sea	$187	3
Sea Ledges	14x17	Sea	$176	4
Sea Ledges	16X20	Sea	$187	5
Sea Ledges	16x20	Sea	$187	5
Sea Ledges	20x28	Sea	$286	3
Sea Ledges	9x15	Sea	$198	4
Surf Off Swampscott	12x18	Sea	$231	3
Swirling Seas	13X16	Sea	$308	5
Swirling Seas	13x16	Sea	$176	4
Swirling Seas	13x16	Sea	$198	5
Swirling Seas	13x16	Sea	$440	5
Swirling Seas	14x20	Sea	$375	5
Swirling Seas	15x22	Sea	$413	5
Swirling Seas	18x22	Sea	$176	5
The Endless Battle	12x15	Sea	$308	3
The Rock Bound Coast	16x20	Sea	$165	3
The Sea Ledges of New England	13x16	Sea	$286	5
Untitled Seascape	5x7	Sea	$121	4
Untitled Seascape	5x7	Sea	$165	4
Untitled Seascape	5x7	Sea	$110	3
Untitled Seascape	7X11	Sea	$99	4
Untitled Seascape	7X11	Sea	$116	3

145

Untitled Seascape	7x11	Sea	$110	4
Untitled Seascape	7x11	Sea	$105	4
Untitled Seascape	7x11	Sea	$132	5
Untitled Seascape	7x11	Sea	$110	4
Untitled Seascape	7x11	Sea	$61	3
Untitled Seascape	7x11	Sea	$105	3
Untitled Seascape	7x9	Sea	$143	2
Untitled Seascape	7X9	Sea	$55	3
Untitled Seascape	8x10	Sea	$105	5
Untitled Seascape	8x12	Sea	$154	4
Untitled Seascape	9x11	Sea	$165	4
White Waves	11X17	Sea	$143	5
Large Snow Scene	14x17	Snow	$1,705	5
Mt Ranier	8x10	Snow	$275	4
Mt. Ranier in July	10X12	Snow	$352	4
The Orchard in Winter	10x16	Snow	$633	5
Untitled Snow Scene	7X9	Snow	$297	5
Untitled Snow Scene	7x9	Snow	$253	5
Untitled Snow Scene	7x9	Snow	$209	5
Untitled Snow Scene	7x9	Snow	$275	4
Untitled Snow Scene	9x11	Snow	$473	5
Untitled Snow Scene	7x9	Snow	$330	5
Untitled Snow Scene	7x9	Snow	$550	5
Untitled Snow Scene	7x9	Snow	$495	5
Untitled Snow Scene	7X9	Snow	$506	5
Untitled Snow Scene	7x9	Snow	$165	4
Untitled Snow Scene	7x9	Snow	$209	5
Untitled Snow Scene	7X9	Snow	$286	5
Untitled Snow Scene	7x9	Snow	$396	5
Untitled Snow Scene	7x9	Snow	$352	5
Untitled Snow Scene	6x8	Snow	$308	5
Untitled Snow Scene	8x10	Snow	$209	5
Untitled Snow Scene	7x10	Snow	$198	3
Untitled Snow Scene	5x7	Snow	$231	5
Untitled Snow Scene	6x8	Snow	$297	4
Untitled Snow Scene	7x9	Snow	$198	4
Untitled Snow Scene	3x4	Snow	$105	4
Untitled Snow Scene	5x7	Snow	$253	5
Untitled Snow Scene	7x9	Snow	$198	5
Untitled Snow Scene	7x9	Snow	$176	4
Winter Overcoat	10x12	Snow	$275	3

A Village Coach	11x14	Stage	$1,128	4
An Eventful Journey	14x17	Stage	$1,155	5
An Eventful Journey	12x15	Stage	$484	4
An Eventful Journey	14x17	Stage	$688	5
Rapid Transit	13x16	Stage	$528	5
The Eventful Journey	14x17	Stage	$715	4
A Benedict Door	13X16	Other	$209	5
A Blue Ridge Orchard	12x16	Other	$198	5
A Border at Montibello	13x16	Other	$450	5
A Border at Montibello	13x16	Other	$319	5
A Call at the Manor	13x16	Other	$275	5
A Call in State	10x12	Other	$88	3
A Call on the Parson	14x17	Other	$143	5
A Critical Examination	12X16	Other	$319	5
A Critical Examination	12x15	Other	$66	2
A Dividing Path	11x17	Other	$143	5
A Florida Sunrise	13x17	Other	$440	5
A Flowering Fence	10x13	Other	$72	5
A Forest Brook	15x18	Other	$121	3
A Gable of Roses	13x16	Other	$264	5
A Gable of Roses	13x16	Other	$286	5
A Garden Enclosed	8x14	Other	$99	4
A Garden in a Garden	10x13	Other	$121	4
A Garden Lane	13x16	Other	$176	5
A Garden of Lilies	10x13	Other	$187	4
A Georgian Doorway, Mass.	11x14	Other	$176	5
A Green Carpeted Parlor	10x13	Other	$66	5
A Litchfield Door	13x16	Other	$220	5
A Memory of Childhood	13x16	Other	$187	5
A Memory of Childhood	14x17	Other	$154	3
A Memory of Childhood	13X17	Other	$99	3
A Memory of Childhood	13x17	Other	$105	3
A Path Among Blossoms	10x12	Other	$28	3
A Pause in the Path	10x13	Other	$121	4
A Pennsylvania College Portal	13x16	Other	$440	5
A Pennsylvania Hillside	10x12	Other	$523	5
A Pool at Sandwich	13x16	Other	$198	3
A Providence Idyll	10x13	Other	$99	4
A River Window	9x11	Other	$143	3
A Rockhill Medley	13x16	Other	$275	4
A Rockhill Medley	13x16	Other	$220	5

A Southern Highway	14x17	Other	$132	4
A Southern Puritan	13X16	Other	$550	5
A Southern Puritan	12x14	Other	$363	4
A Southern Puritan	13x16	Other	$220	3
A Stair of Stone	13x16	Other	$132	3
A Tap at the Squire's Door	14x17	Other	$99	3
A Tap at the Squire's Door	13X16	Other	$187	4
A Temple Valley	13x16	Other	$143	5
A Vergennes Front, Vermont	13x16	Other	$176	5
Afternoon Shadows	13x15	Other	$176	3
All in a Garden Fair	11x17	Other	$154	5
All in a Garden Fair	11x17	Other	$165	5
All in a Garden Fair	11X17	Other	$143	5
All in a Garden Fair	13x17	Other	$165	3
All in a Garden Fair	14x17	Other	$94	3
All in a Garden Fair	9x11	Other	$143	3
All in a Garden Fair	9x16	Other	$50	3
An Affectionate Greeting	3x5	Other	$94	4
An Affectionate Greeting	12x16	Other	$242	5
An Affectionate Greeting	5x7	Other	$94	4
An Afternoon Stroll	13x16	Other	$209	5
An Ancient Fireplace	8x10	Other	$495	5
An August Garden	11x17	Other	$209	5
An August Garden	10x16	Other	$187	5
An Ivied Porch	11x14	Other	$88	3
An Old Fashioned Paradise	14x17	Other	$418	5
An Old Fashioned Paradise	11x14	Other	$110	3
An Old Fashioned Paradise	11x17	Other	$121	3
An Old Fashioned Paradise	14x17	Other	$297	3
Anno 1820	13x16	Other	$198	5
As it was in 1700	13X16	Other	$242	5
Awaiting an Opening	13x17	Other	$209	4
Balch House, Beverly	11x14	Other	$50	3
Bordered in Blue	10x13	Other	$44	5
Bridesmaid's Rehearsal	10x12	Other	$220	5
Callers at the Squires	13X16	Other	$83	2
Camden Clouds	14x17	Other	$660	5
Camden Harbor	13x16	Other	$143	4
Camden Harbor	12x16	Other	$165	5
Close-Framed Doorway	8x10	Other	$105	5
Close-Framed Village	7x9	Other	$94	3
Close-Framed Wayside Inn	5x7	Other	$28	4
Come into the Garden	16x20	Other	$385	5
Dogwood Roadside, Virginia	12x16	Other	$132	3

Door with Detached Side Lights	13x16	Other	$319	5
Double Doorway Picture	13x16	Other	$350	5
Double Exterior Scene	4x6	Other	$105	5
El Capitan	11X17	Other	$220	4
Far Dixie	9x13	Other	$220	5
Flower Laden	13x16	Other	$341	5
Flower Laden	13x16	Other	$375	5
Floweree Approach	8x10	Other	$94	5
For the Visitor	11X14	Other	$121	3
Framed Pen & Ink Drawing by EJD	10X14	Other	$297	3
From Maiden's Cliff	13x17	Other	$176	5
Front, Graves-Redfield House	13x16	Other	$495	5
Gambrel Gables	13x16	Other	$275	5
Going Forth to Conquer	13x16	Other	$198	4
Heathville Honeysuckle	13x16	Other	$165	5
Hidden View of Samoset Garden	14x17	Other	$99	5
Highway or Byway?	16x20	Other	$429	5
Hingham's Lane	14x17	Other	$88	5
Home Charm, Garfield Place	13X16	Other	$352	5
In Olden Time	11x17	Other	$176	5
Inclining Palmettos	11x17	Other	$330	4
Into the South	14x17	Other	$264	4
Ivy and Rose Cloister	12X14	Other	$154	3
Ivy and Rose Cloister	13x16	Other	$352	5
Ivy and Rose Cloister	14X17	Other	$330	5
Ivy and Rose Cloister	9X12	Other	$61	3
Jane	12x18	Other	$77	4
June Arches	10x13	Other	$105	4
Large Untitled Scene	20x24	Other	$165	4
Large °Where Grandma Was Wed'	18x22	Other	$275	3
Late August	10x13	Other	$99	4
Locust Cottage	10x12	Other	$88	3
Maidenly Pleasures	11x14	Other	$187	5
Memories of Childhood	11x14	Other	$121	4
Montibello Arbors	13x16	Other	$209	5
Montibello Terraces	13x16	Other	$350	5
Nutting House, Providence	14x17	Other	$440	5
Nuttinghame Blossoms	14x17	Other	$275	5
Nuttinghame Blossoms	13x16	Other	$88	4
Nuttinghame Pool	11x14	Other	$165	3
Oak and Resurrection Fern	11x14	Other	$88	3
Oak Spandrel Ceiling, Kenmore	13x16	Other	$286	5
Oak & Resurection Fern	14X18	Other	$110	3
Old England in New	16x20	Other	$176	5

Opening Summer	10x13	Other	$66	5
Original Dennison Plant, Bruns	13x16	Other	$165	5
Out of the Garden	11x17	Other	$127	4
Palm Spandrel Ceiling, Kenmore	13x16	Other	$330	5
Palms by a Pool	13x16	Other	$176	5
Paradise Portal	11x14	Other	$264	5
Paradise Portal	16x20	Other	$330	5
Paradise Valley	9x13	Other	$83	4
Primping	11x14	Other	$242	5
Providence Pond	10x13	Other	$88	5
Resting at the Old Stoop	17X21	Other	$253	5
Resting at the Old Stoop	14x17	Other	$99	3
Resting at the Old Stoop	13x16	Other	$198	4
Resting at the Stoop	12x16	Other	$88	3
Rose Trees at Montibello	13x16	Other	$231	5
Rowing up the Battenkill	13x20	Other	$198	3
Salem Beautiful	13x16	Other	$132	4
Salem Beautiful	13x16	Other	$330	5
Salem Beautiful	14x17	Other	$143	5
Salem Dignity	12X16	Other	$308	3
San Gabriel	11x14	Other	$253	4
Serried Evergreen	10x13	Other	$83	5
Silas Deane Door, Wethersfield	13x16	Other	$143	5
Southern Village Street	14x17	Other	$220	5
Spanish Moss	14x17	Other	$187	5
Spanish Moss	14x17	Other	$231	5
Spinning	13x16	Other	$121	5
Spring Fashions	8X12	Other	$385	3
St John's Church, Portsmouth	13x16	Other	$385	5
Summer Retreat	10x13	Other	$83	4
Summer Retreat	10x13	Other	$66	5
Sunset Palmetto's	14x17	Other	$176	3
Sunshine and Wind	13x16	Other	$121	3
Thanksgiving	11/14	Other	$198	3
The Admiral's Door	16x20	Other	$308	5
The Arch at the Inn	13x16	Other	$231	5
The Arch at the Inn	13x16	Other	$176	5
The Bells of San Gabriel	11x14	Other	$99	5
The Budding Years	14x17	Other	$77	3
The Days of Old	11x17	Other	$204	5
The Days of Old	14x17	Other	$132	5
The Days of Old	14x17	Other	$209	4
The Disappearing Walk	10x13	Other	$83	4
The Fens	9x18	Other	$165	3

The Flower Maiden	11X17	Other	$275	5
The Flower Missionary	8x14	Other	$154	4
The Flower Missionary	11x17	Other	$121	4
The Going Forth of Betty	11x14	Other	$99	4
The Going Forth of Betty	11x14	Other	$132	3
The Going Forth of Betty	13x17	Other	$176	5
The Going Forth of Betty	13x16	Other	$143	3
The Langdon Door	13x16	Other	$209	4
The Langdon Door	13x16	Other	$83	5
The Langdon Door	14x17	Other	$198	4
The Langdon Door	14X17	Other	$341	5
The Manchester Battenkill	17x21	Other	$143	5
The Merchant's Daughter	14x17	Other	$286	5
The Natural Bridge	16x20	Other	$275	5
The Natural Bridge	9x11	Other	$105	4
The Natural Bridge	13x16	Other	$143	5
The Original Dennison House	14x17	Other	$94	3
The Original Dennison House	14x17	Other	$473	5
The Path Gate	10x13	Other	$88	4
The Pond Path	20x30	Other	$275	5
The Retreat	10x13	Other	$44	4
The Sallying of Sally	11x14	Other	$94	3
The Sallying of Sally	12x16	Other	$110	3
The Sallying of Sally	13x17	Other	$143	4
The Sallying of Sally	14x17	Other	$220	4
The Sallying of Sally	14x17	Other	$176	5
The Sallying of Sally	14x17	Other	$176	3
The San Gabriel Mission	9x15	Other	$165	3
The San Gabriel Mission	9X15	Other	$171	3
The Tomoka River, Florida	14x17	Other	$143	5
The Tomaka River, Florida	14x17	Other	$99	5
The Village Vale	13x16	Other	$187	5
The Waiting Bucket	9x11	Other	$175	4
The Wayside Inn Approach	11x14	Other	$286	5
The Wayside Oak	13X16	Other	$330	5
Tiger Lilies and Elder	13x16	Other	$418	5
Tiny Mirror in Metal Frame	1X2	Other	$121	4
To Meet Me	11x17	Other	$176	5
To the End Porch	12X16	Other	$116	4
Two Centuries	11x14	Other	$132	5
Under the Drooping Bough	10X12	Other	$105	5
Under the Drooping Bough	9x11	Other	$83	5
Undercliff Drive	17x21	Other	$198	3
Untitled Archway	7x9	Other	$105	5

Untitled Archway	6x8	Other	$55	4
Untitled B&W	10x12	Other	$61	3
Untitled Canoe	7x9	Other	$83	4
Untitled Children	n/a	Other	$198	2
Untitled Doorway	8X12	Other	$77	3
Untitled Exterior	8x12	Other	$55	4
Untitled Farmhouse	7x11	Other	$83	4
Untitled Garden	6x8	Other	$88	4
Untitled Garden	6x8	Other	$61	5
Untitled Garden	6x8	Other	$143	5
Untitled Garden	6x8	Other	$50	4
Untitled Garden	7x9	Other	$94	4
Untitled Garden	7x9	Other	$77	4
Untitled Garden	8X10	Other	$44	4
Untitled Garden	8x10	Other	$165	5
Untitled Girl at Door	5x10	Other	$61	4
Untitled Girl Leaving House	11x14	Other	$132	4
Untitled girl on porch	11x14	Other	$176	4
Untitled Girls at Doorway	9X11	Other	$41	3
Untitled House	7x11	Other	$143	5
Untitled House	7x11	Other	$61	4
Untitled House	7X11	Other	$143	5
Untitled House	7x9	Other	$44	4
Untitled House	7x9	Other	$99	5
Untitled House	10x12	Other	$143	3
Untitled House	12x14	Other	$132	3
Untitled Ladies at Doorway	5x7	Other	$94	4
Untitled Lady at Door	14x17	Other	$55	3
Untitled Lady Near House	5x7	Other	$110	4
Untitled Pennsylvania Farmhouse	8x10	Other	$165	5
Untitled Pennsylvania Farmhouse	8X10	Other	$198	5
Untitled Village	8x12	Other	$55	4
Untitled °Natural Bridge'	8X10	Other	$55	4
Untitled °Natural Bridge'	8x10	Other	$83	4
Untitled °Natural Bridge'	8X10	Other	$83	5
Valley Forge Headquarters	10x12	Other	$253	5
Wadsworth House	13x16	Other	$176	5
Waiting	13x16	Other	$375	5
Wallace Nutting Collage	16X20	Other	$176	5
Wallace Nutting Notes	10x12	Other	$33	3
Warner House	13x16	Other	$154	5
Warner Parlor, Portsmouth, NH	13X16	Other	$198	5
Washington Cherry Blossoms	7x10	Other	$132	3
Way Down in Dixie	11x17	Other	$94	3

152

Wayside Inn From Highway	11x14	Other	$308	5
Wayside Inn Garden	12x14	Other	$176	5
Wentworth Mansion Entrance	13X16	Other	$187	5
Where Grandma Was Wed	11X14	Other	$297	4
Where Grandma Was Wed	15x22	Other	$165	4
Where Grandma Was Wed	18x22	Other	$396	5
Whitehall Blossoms	12x16	Other	$363	5
Winslow Water	13x16	Other	$176	4
Wisteria Gate	10x18	Other	$275	3
Yellow Beeches Creek	14x17	Other	$187	5
A Call in State	13x16	Other	$242	4
Horizontal Mirror/Waterfalls	13x34	Mirror	$616	4
Mirror with °Comfort and a Cat'	14X40	Mirror	$770	5
Mirror with Exterior Scene	7x20	Mirror	$94	3
Mirror with Exterior Scene	8X28	Mirror	$187	4
Mirror with Exterior Scene	7x13	Mirror	$83	4
Mirror with Interior Scene	10x26	Mirror	$198	4
Mirror with Interior Scene	12x36	Mirror	$297	5
Mirror with Interior Scene	22x44	Mirror	$330	5
Mirror with Interior Scene	5x14	Mirror	$187	5
Mirror with Interior Scene	8x24	Mirror	$319	4
Mirror with Interior Scene	16x40	Mirror	$413	4
Mirror with Interior Scene	14x30	Mirror	$451	5
Mirror with Interior Scene	8x33	Mirror	$176	3
Mirror with Interior Scene	20x53	Mirror	$341	5
Mirror with °Skirmishing'	10x36	Mirror	$743	5
Tray with °A Barre Brook'	10x16	Tray	$116	4
Tray with °A NE Road in May'	10x16	Tray	$66	3
Tray with °Honeymoon Windings'	10x16	Tray	$72	4
Tray with Seascape	12x16	Tray	$440	5
Tray with Exterior Scene	8X12	Tray	$132	5
Tray with Exterior Scene	12X20	Tray	$198	5
Tray with °Spring in the Dell'	10x16	Tray	$28	2
Tray with °Coming Out of Rosa'	11x14	Tray	$176	5
Tiny Tray with Interior Scene	3X4	Tray	$143	5

Uncolored **Proof Sheet**

Deluxe Edition of **The Furniture Treasury**

154

Miscellaneous Wallace Nutting Memorabilia

Calendar, 1918	Misc	$83	3
Calendar, 1925	Misc	$242	5
Calendar, 1930	Misc	$154	5
Calendar, 1931	Misc	$77	4
Calendar, 1931	Misc	$121	4
Calendar, Year Unknown	Misc	$165	4
Card, Easter	Misc	$176	4
Card, Greeting	Misc	$143	5
Card, Greeting	Misc	$72	5
Card, Greeting	Misc	$61	5
Card, Greeting	Misc	$176	2
Card, Greeting	Misc	$154	5
Card, Greeting	Misc	$77	4
Card, Greeting	Misc	$83	5
Card, Greeting, Folding	Misc	$83	5
Card, Greeting, Folding	Misc	$94	5
Card, Greeting, from Mrs Nutting	Misc	$154	5
Card, Greeting, Silhouette	Misc	$28	5
Card, Greeting, Silhouette (6)	Misc	$66	5
Card, Greeting, with Snow Scene	Misc	$171	5
Card, Greeting, with °Pine Landing'	Misc	$47	4
Card, Greeting, without Verse	Misc	$39	5
Card, Greeting, without Verse	Misc	$25	4
Card, Greeting with Exterior	Misc	$39	4
Card, Mother's Day, Colored	Misc	$72	4
Card, Mother's Day, Colored	Misc	$83	5
Card, Mother's Day, Colored	Misc	$99	4
Card, Mother's Day, Colored	Misc	$66	5
Card, Mother's Day, Colored	Misc	$44	4
Card, Mother's Day, Colored	Misc	$83	4
Card, Mother's Day, Colored	Misc	$44	4
Card, Mother's Day, Colored	Misc	$83	5
Card, Mother's Day, Colored	Misc	$30	4
Card, Mother's Day, Colored	Misc	$99	4
Card, Mother's Day, Colored	Misc	$50	5
Card, Mother's Day, Silhouette	Misc	$39	4
Card, Mother's Day, Silhouette	Misc	$66	4
Card, Mother's Day, Silhouette	Misc	$72	5
Card, Xmas	Misc	$83	4
Card, Xmas	Misc	$77	4

Card, Xmas, Card & Envelope	Misc	$242	4
Card, Xmas, Pentype Silhouette	Misc	$33	4
Card, Xmas, Snow, Salesman's Sample	Misc	$209	4
Cards, Greeting, Pentype (3)	Misc	$116	4
Cards, Xmas, Pentype (5)	Misc	$143	5
Cards, Xmas, Pentype (5)	Misc	$55	5
Cards, Xmas, Pentype (5)	Misc	$69	4
Checks, Page from WN Checkbook	Misc	$165	5
Checks, Page from WN Checkbook (3)	Misc	$50	4
Collage, °All Smiles	Misc	$88	4
Colorist's Coloring Instructions	Misc	$550	5
Colorist's Coloring Instructions	Misc	$198	5
Colorist's Coloring Instructions	Misc	$242	5
Colorist's Coloring Instructions	Misc	$286	5
Colorist's Coloring Instructions	Misc	$506	5
Colorist's Porcelin Paint Tray	Misc	$132	4
Colorist's Porcelin Paint Tray	Misc	$88	5
Colorist's Porcelin Paint Tray	Misc	$121	4
Colorist's Porcelin Paint Tray	Misc	$88	4
Colorist°s Water Colors, Box	Misc	$242	4
Copper Engraving Plate	Misc	$110	5
Early American Ironwork Book	Misc	$231	5
Esther Svenson Exterior Scene	Misc	$94	4
Esther Svenson Exterior Scene	Misc	$50	3
Framed Wallace Nutting Checks	Misc	$105	4
Furniture Catalog, 1926	Misc	$220	5
Furniture Catalog, 1927-28	Misc	$47	4
Furniture Catalog, 1927-28	Misc	$66	4
Furniture Catalog, 1927-28	Misc	$61	5
Furniture Catalog (Final) 1937	Misc	$83	5
Furniture Catalog (Final) 1937	Misc	$132	5
Furniture Catalog (Final) 1937	Misc	$77	4
Furniture Catalog (Recov. Ed) 1937	Misc	$275	5
Furniture Catalog (Sup Ed), 1930	Misc	$110	4
Furniture Catalog (Sup Ed), 1930	Misc	$209	4
Furniture Catalog (Sup Ed), 1930	Misc	$94	4
Glass Wallace Nutting Sign	Misc	$550	5
Glass Wallace Nutting Sign	Misc	$525	5
Letter, Nutting/Stickley	Misc	$633	5
Letter, Wallace Nutting Signature	Misc	$242	5
Letter, Wallace Nutting Signature	Misc	$468	5
Letter, Wallace Nutting Signature	Misc	$116	5
Letter, Wallace Nutting Signature	Misc	$99	5
Letter, Wallace Nutting Signature	Misc	$468	5

Letter, Wallace Nutting Signature	Misc	$88	5
Magazine Article, 1904	Misc	$41	4
Manuscript, °Gates', 18 Pages	Misc	$231	5
Map of WN's Birthplace	Misc	$17	4
Map of WN's Birthplace (Stow)	Misc	$28	4
Misc, Card & Notes	Misc	$88	4
Misc, Mrs Nutting: Picture/Card	Misc	$165	5
Misc, Picture & Film Negative	Misc	$22	4
Misc, WN Paper Items	Misc	$39	5
Misc, WN Paper Items	Misc	$99	4
Misc, WN Paper Items	Misc	$39	5
Misc, WN Paper Items	Misc	$39	5
Model Picture	Misc	$99	5
Model Picture	Misc	$99	5
Model Picture	Misc	$66	5
Model Picture	Misc	$55	5
Model Picture	Misc	$99	5
Model Pictures, 2x3 (9)	Misc	$272	5
Model Pictures, Unmounted (10)	Misc	$303	5
Model Pictures, Unmounted (10)	Misc	$550	5
Model Pictures, Unmounted (10)	Misc	$385	5
Model Pictures, Unmounted (10)	Misc	$358	5
Model Pictures (6)	Misc	$198	5
Model Pictures (7)	Misc	$212	5
Model Pictures (7)	Misc	$404	5
Negative, Celluloid (2)	Misc	$110	4
Negative, Glass	Misc	$220	5
Negative, Glass	Misc	$143	5
Negative, Glass	Misc	$275	5
Negative, Glass	Misc	$99	4
Negative, Glass	Misc	$253	5
Original Silhouette Drawing	Misc	$116	5
Page of Nuttinghame Pictures	Misc	$330	5
Parke-Bernet Auction Catalog	Misc	$94	4
Photo of 1928 WN Studio Employees	Misc	$110	5
Photograph, Architectural (1)	Misc	$83	5
Photographs, WN Colorists (5)	Misc	$88	4
Picture Catalog, 1908	Misc	$325	5
Picture Catalog, 1908	Misc	$385	5
Picture Catalog, 1912	Misc	$154	5
Picture Catalog, 1912	Misc	$176	5
Picture Catalog, 1937	Misc	$253	5
Picture Catalog, Expansible, 1915	Misc	$198	5
Picture Catalog, Expansible, 1915	Misc	$176	3

157

Picture Catalog, Expansible, 1915	Misc	$264	4
Picture of WN in Oval Frame	Misc	$33	4
Picture of Mr & Mrs Nutting	Misc	$28	4
Pirate Prints (4)	Misc	$31	3
Postcard, Wallace Nutting	Misc	$99	5
Postcard of Nuttingholme	Misc	$127	4
Process Print Sign	Misc	$94	5
Proof Picture-10x13	Misc	$72	5
Proof Sheet-Floral Scenes	Misc	$88	5
Proof Sheet-Framed	Misc	$94	5
Proof Sheet-Framed	Misc	$55	4
Proof Sheet-Framed	Misc	$55	5
Proof Sheet-Framed	Misc	$55	5
Proof Sheet-Framed	Misc	$83	5
Proof Sheet-Unframed	Misc	$83	5
Proof Sheet-Unframed	Misc	$55	4
Sign, Wallace Nutting, Paper	Misc	$121	5
Stationary, Wallace Nutting Co.	Misc	$30	5
The Return From Labor-Child	Misc	$176	4
Tombstone Rubbing, WN, Copy	Misc	$14	3
Tombstone Rubbing, WN, Original	Misc	$55	4
Tray, Small, with Exterior Scene	Misc	$77	5
Tray, Small, with Interior Scene	Misc	$83	5
Tray, Small, with Snow Scene	Misc	$154	5
Triple Picture Grouping	Misc	$440	5
Unmounted Pictures, B&W (70)	Misc	$611	5
Unmounted Pictures, B&W Glossy (1	Misc	$165	5
Unmounted Pictures, B&W Glossy (10)	Misc	$220	5
Unmounted Pictures, B&W Glossy (10)	Misc	$66	5
Unmounted Pictures, B&W (10)	Misc	$358	4
Unmounted Pictures, B&W (10)	Misc	$220	5
Unmounted Pictures, B&W (7)	Misc	$173	4
Unmounted Pictures, Colored (10)	Misc	$330	5
Unmounted Pictures, Colored (10)	Misc	$523	5
Unmounted Pictures, Colored (10)	Misc	$248	5
Unmounted Pictures, Colored (10)	Misc	$451	5
Unmounted Pictures, Colored (16)	Misc	$446	3
Unmounted Pictures, Eng B&W (10)	Misc	$138	5
Unmounted Pictures (5)	Misc	$220	4
Up At Vilas Farm.	Misc	$3,135	5
WN Picture, Framed	Misc	$72	4
°Going Home for Christmas'	Misc	$50	3
°Old New England Pictures' Book	Misc	$3,080	3
Thermometer (Watersmeet)	Misc.	$33	3

Process Prints

5 Process Prints (1 Lot)	12x15	Process	$14	5
8 Process Prints (1 Lot)	12x15	Process	$88	3
A Barre Brook	16x20	Process	$30	4
A Barre Brook	16x20	Process	$22	3
A Barre Brook	16x20	Process	$28	4
A Barre Brook	16x20	Process	$50	4
A Barre Brook	16x20	Process	$50	4
A Garden of Larkspur	12x15	Process	$17	4
A Garden of Larkspur	16x20	Process	$33	4
A Garden of Larkspur	16X20	Process	$72	4
A Sheltered Brook	12x15	Process	$19	4
A Sheltered Brook	16X20	Process	$39	4
A Sheltered Brook	16x20	Process	$66	4
A Sheltered Brook	16x20	Process	$44	4
A Sheltered Brook	16x20	Process	$22	4
Among October Birches	16x20	Process	$50	3
Among October Birches	16x20	Process	$14	3
Bonny Dale	16X20	Process	$83	4
Bonny Dale	16x20	Process	$33	4
Bonny Dale	16x20	Process	$88	4
Decked as a Bride	16x20	Process	$28	4
Decked as a Bride	16x20	Process	$50	3
Decked as a Bride	16x20	Process	$66	4
Decked as a Bride	16x20	Process	$44	3
Decked as a Bride	16X20	Process	$22	4
Nethercote	16x20	Process	$39	4
Nethercote	16x20	Process	$61	4
Nethercote	16x20	Process	$22	4
Nethercote	12X15	Process	$11	3
Primrose Cottage	16x20	Process	$28	4

Silhouettes

Abe Lincoln/Mary Todd Silhouettes	4x5	Sil	$187
Framed Silhouette Card	4x5	Sil	$61
George Washington Silhouette	4x5	Sil	$83
Martha Washington Silhouette	4x5	Sil	$50
George & Martha Silhouettes	3x4	Sil	$121
George & Martha Silhouettes	4x5	Sil	$132
Group of 10 Unframed Silhouettes	4x4	Sil	$88
Group of 12 Unframed Silhouettes	4x4	Sil	$231
Group of 8 Unframed Silhouettes	7x8	Sil	$242
Pair of Silhouettes	7x8	Sil	$176
Pair of Silhouettes	4X4	Sil	$77
Pair of Silhouettes	5x5	Sil	$77
Pair of Silhouettes	4X4	Sil	$105
Pair of Silhouettes	4X4	Sil	$61
Pair of Silhouettes	4x4	Sil	$77
Pair of Silhouettes	4x4	Sil	$99
Pair of Silhouettes	4X4	Sil	$121
Pair of Silhouettes	4x4	Sil	$77
Pair of Silhouettes	4X4	Sil	$83
Pair of Silhouettes	4x4	Sil	$88
Pair of Silhouettes	4x4	Sil	$110
Pair of Silhouettes	4x4	Sil	$99
Pair of Silhouettes	3x4	Sil	$83
Pair of Silhouettes	4x4	Sil	$66
Sil Xmas Card of Mr/Mrs Nutting	6x8	Sil	$110
Silhouette	7x8	Sil	$39
Silhouette	4x4	Sil	$33
Silhouette	7x8	Sil	$91
Silhouette	4x4	Sil	$25
Silhouette	7x8	Sil	$41
Silhouette	7x8	Sil	$50
Silhouette	4x4	Sil	$33
Silhouette	7X8	Sil	$33
Silhouette	7X8	Sil	$25
Silhouette	7X8	Sil	$28
Silhouette	4x4	Sil	$33
Silhouette	7x8	Sil	$22
Silhouette	7X8	Sil	$25
Silhouette	7x8	Sil	$22
Silhouette	7X8	Sil	$25

Silhouette	4x4	Sil	$33	4
Silhouette	4x4	Sil	$28	4
Silhouette	4x4	Sil	$30	4
Silhouette	7x8	Sil	$39	4
Silhouette	7x8	Sil	$55	4
Silhouette	4x4	Sil	$39	4
Silhouette	4x4	Sil	$30	4
Silhouette	7x8	Sil	$66	4
Silhouette	4x4	Sil	$33	4
Silhouette	4x4	Sil	$44	4
Silhouette		Sil	$19	5
Silhouette	7x8	Sil	$72	5
Silhouette	4x4	Sil	$28	4
Silhouette	7x8	Sil	$83	5
Silhouette	7x8	Sil	$77	4
Silhouette	4x4	Sil	$33	4
Silhouette	4x4	Sil	$25	4
Silhouette	7x8	Sil	$41	4
Silhouette	/x8	Sil	$66	4
Silhouette	7X8	Sil	$22	5
Silhouette	7x8	Sil	$72	4
Silhouette	4x4	Sil	$55	4
Silhouette	7x8	Sil	$72	4
Silhouette	7x8	Sil	$44	4
Silhouette-Girl at Cheval Mirror	5x5	Sil	$44	4
Silhouette-Girl at Vanity	5x5	Sil	$44	4
Silhouette-Girl by Statue	5x5	Sil	$44	4
Silhouette-Round Frame	5x5	Sil	$61	5
Silhouette-Round Frame	5x5	Sil	$121	5

Wallace Nutting Books

American Windsors	Book	$88	4
American Windsors	Book	$165	5
American Windsors	Book	$61	4
American Windsors	Book	$77	5
Connecticut Beautiful	Book	$44	4
Connecticut Beautiful	Book	$30	4
Connecticut Beautiful	Book	$72	4
Connecticut Beautiful	Book	$28	3
Connecticut Beautiful	Book	$61	4
Connecticut Beautiful	Book	$39	4
England Beautiful	Book	$47	4
England Beautiful	Book	$39	4
England Beautiful	Book	$77	5
England Beautiful	Book	$154	5
England Beautiful	Book	$83	4
Furniture of the Pilgrim Century	Book	$94	4
Furniture of the Pilgrim Century	Book	$72	5
Furniture Treasury, 2 Vol, 1948 Ed	Book	$55	5
Furniture Treasury, 3 Vol, 1948 Ed	Book	$132	4
Furniture Treasury, 3 Vol, 1st Ed	Book	$297	5
Furniture Treasury, 3 Vol, 1st Ed	Book	$121	5
Furniture Treasury, 3 Vol, 1st Ed	Book	$209	4
Furniture Treasury, 3 Vol, 1st Ed	Book	$231	4
Furniture Treasury, 3 Vol, 1st Ed	Book	$578	5
Ireland Beautiful	Book	$50	4
Ireland Beautiful	Book	$72	5
Ireland Beautiful	Book	$33	4
Maine Beautiful	Book	$33	4
Maine Beautiful	Book	$50	4
Maine Beautiful	Book	$44	4
Maine Beautiful	Book	$36	4
Massachusetts Beautiful	Book	$25	4
Massachusetts Beautiful	Book	$25	4
Massachusetts Beautiful	Book	$44	4
Massachusetts Beautiful	Book	$50	4
Massachusetts Beautiful	Book	$39	4
Massachusetts Beautiful	Book	$41	4
New Hampshire Beautiful	Book	$61	4
New Hampshire Beautiful	Book	$61	4
New York Beautiful	Book	$36	4

New York Beautiful	Book	$28	4
New York Beautiful	Book	$72	4
New York Beautiful	Book	$99	4
New York Beautiful	Book	$55	4
Pathways of the Puritans	Book	$143	4
Pathways of the Puritans	Book	$138	4
Pathways of the Puritans	Book	$72	5
Pathways of the Puritans	Book	$58	4
Pathways of the Puritans	Book	$22	2
Pathways of the Puritans	Book	$28	3
Pennsylvania Beautiful	Book	$33	4
Pennsylvania Beautiful	Book	$33	4
Pennsylvania Beautiful	Book	$55	4
Pennsylvania Beautiful	Book	$66	4
Pennsylvania Beautiful	Book	$33	4
Pennsylvania Beautiful	Book	$50	5
Photographic Art Secrets	Book	$99	5
Photographic Art Secrets	Book	$220	5
Photographic Art Secrets	Book	$121	5
Set of 10 1st Ed States Beaut Books	Book	$495	4
Set of 10 2nd Ed States Beaut Books	Book	$209	5
Set of 10 2nd Ed States Beaut Books	Book	$198	4
Set of 10 2nd Ed States Beaut Books	Book	$220	4
States Beautiful Reproductions (5)	Book	$50	4
The Clock Book	Book	$47	4
The Clock Book	Book	$44	4
The Clock Book	Book	$55	4
The Clock Book	Book	$28	4
The Clock Book	Book	$77	5
The Clock Book	Book	$33	4
The Cruise of the 800	Book	$110	4
The Cruise of the 800	Book	$121	4
Vermont Beautiful	Book	$40	4
Vermont Beautiful	Book	$45	5
Vermont Beautiful	Book	$44	5
Vermont Beautiful	Book	$39	4
Virginia Beautiful	Book	$61	4
Virginia Beautiful	Book	$72	4
Virginia Beautiful	Book	$55	4
Wallace Nutting's Biography	Book	$72	5
Wallace Nutting's Biography	Book	$83	4
Wallace Nutting's Biography	Book	$83	4
Wallace Nutting's Biography	Book	$66	5
Wallace Nutting's Biography	Book	$77	5

About the Author

Michael Ivankovich has been collecting Wallace Nutting pictures, books, and furniture for more than 15 years. Like many collectors, he first began collecting Wallace Nutting's hand-colored photographs at local Flea Markets. Today he is the largest collector/dealer of Wallace Nutting in the country.

This specialization in Wallace Nutting pictures led to his first book in 1984, **The Price Guide to Wallace Nutting Pictures.** The 2nd edition of this book was released in 1986, the 3rd edition in 1989, and this new 4th edition in 1991.

He has also published four other books on Wallace Nutting...**The Wallace Nutting Expansible Catalog** (1987)...**The Alphabetical and Numerical Index to Wallace Nutting Pictures** (1988)...**The Guide to Wallace Nutting Furniture** (1990)...and **The Guide to Wallace Nutting-Like Photographers of the Early 20th Century** (1991).

A frequent lecturer on Wallace Nutting, Mr. Ivankovich has written articles for most major trade papers, has appeared on various radio and television programs, and is frequently consulted by antique columnists throughout the country. As part of his antique business he provides Wallace Nutting Appraisal Services, exhibits at select Antique Shows, and conducts regular Wallace Nutting Auctions throughout the northeast.

Michael Ivankovich is also the author of the book, **The Strategy of Pitching Slow Pitch Softball,** the writer/producer of a full-length video by the same title, and is working on another softball book/video project which will be released later this year. Together with his wife Susan (who has also published 3 books... **The Not-Strictly Vegetarian Cookbook, The Supernatural Dessert Cookbook, and The Sundried Tomato Cookbook),** their company is a leader in the sale of Softball books and videos throughout the country.

They reside in Doylestown, PA with their four children Lindsey, Megan, Jenna, and Nash. He can be reached at P.O. Box 2458, Doylestown, PA 18901.